Audi

Vorspru

BEI UNS BEKOMMT DER KUNDE ALLES AUS EINER HAND. UND ZWAR AUS DER, DIE ER ZU BEGINN UNSERER PARTNERSCHAFT GESCHÜTTELT HAT.

Wir verstehen uns nicht nur als **unabhängige Vermögensverwaltung**, sondern leben dieses Prinzip. Intransparente Produkte lehnen wir strikt ab. Vertrauensvolle Mitarbeiter der VM Vermögens-Management GmbH finden Sie seit 1986 an Standorten wie Düsseldorf, Dortmund, München und Stuttgart. www.vmgruppe.de

Ein Unternehmen der August von Finck Gruppe

VermögensManufaktur

vm.

COOL
MUNICH
Art Architecture Design

edited by Aishah El Muntasser

teNeues

ART

ARCHITECTURE

DESIGN

A
A
D

Content

FALKE

ART

Multiple visits and plenty of time is what you need to come anywhere close to doing justice to Munich's wide range of museums. That's not surprising given that this "city of art," as it became known under King Ludwig I, has a long history. The Antiquarium, Germany's first museum, dates back to the mid 16th century. Visiting the Pinakothek museums is like traveling through centuries of art and cultural history. Be sure not to miss the amazing Museum Brandhorst, opened in 2009. Another absolute must is the Haus der Kunst which hosts internationally renowned exhibitions and promotes political discourse. The historic archive, which documents the building's National Socialist history, and the Goetz Collection, housed in the building's former air raid shelter, round out this unique location. Other high points are Ingvild Goetz' collection in Munich Oberföhring and the city's contemporary "art spaces" with their exciting, interdisciplinary focus, such as MaximiliansForum or Lothringer13.

Man muss mehrmals wiederkommen und sich viel Zeit nehmen, um das großartige Angebot der Münchner Museen auch nur annähernd auszuschöpfen. Kein Wunder, denn die Geschichte der „Kunststadt", so König Ludwig I., geht weit zurück. Das Antiquarium, Deutschlands erstes Museum, datiert aus der Mitte des 16. Jahrhunderts. Allein ein Besuch der Pinakotheken ist wie eine Zeitreise durch die Jahrhunderte der Kunst- und Kulturgeschichte – als krönender Abschluss empfiehlt sich seit 2009 das großartige Museum Brandhorst. Ein anderes absolutes Muss ist das Haus der Kunst mit seinen international beachteten Ausstellungen und der stetigen Förderung auch von politischen Diskursen. Das Historische Archiv, das die NS-Geschichte des Hauses dokumentiert, und die Sammlung Goetz in den ehemaligen Luftschutzkellern komplettieren diesen einzigartigen Ort. Weitere Höhepunkte sind Ingvild Goetz' Sammlung in Oberföhring und die zeitgenössischen „Kunsträume" der Stadt, die eine spannende, interdisziplinäre Ausrichtung haben, wie das Maximilians-Forum oder Lothringer13.

This museum on Jakobsplatz is the perfect place to get to know Munich. Athens on the Isar, Capital of the Movement, Metropolis with Heart—the exhibition "Typically Munich" traces the turbulent history of the city and doesn't shy away from its clichés. The permanent exhibition "National Socialism in Munich" gives the most comprehensive overview yet of the city's darkest chapter. Also worth seeing are the portrait collection and the film museum, which presents excellent film programs.

Das Museum am Jakobsplatz ist der perfekte Ort, um München kennenzulernen. Isar-Athen, Hauptstadt der Bewegung, Weltstadt mit Herz – die Ausstellung „Typisch München" zeichnet die bewegte Geschichte der Stadt nach und macht auch vor ihren Klischees nicht halt. Den bisher umfassendsten Überblick über das dunkelste Kapitel der Stadt dokumentiert die Dauerausstellung „Nationalsozialismus in München". Empfehlenswert sind auch die Porträtsammlung und das Filmmuseum, das exzellente Filmreihen zeigt.

MÜNCHNER STADTMUSEUM

St.-Jakobs-Platz 1 // Altstadt
Tel.: +49 (0)89 23 32 23 70
www.stadtmuseum-online.de

Tue–Sun 10 am to 8 pm

S1–8, U3, U6 Marienplatz

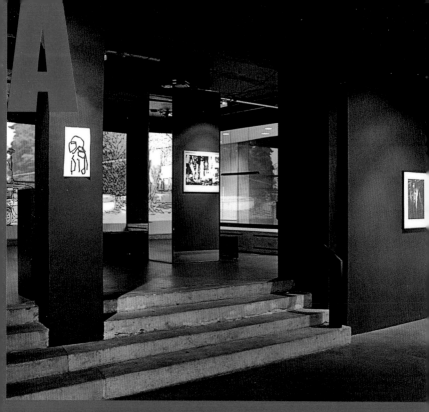

The interior design is the most obvious thing that sets Kirsch & Co apart from conventional galleries: this multimedia playground is not clinically white, but as black as the night. It hosts group and solo exhibitions, and also accommodates local artists with international relevance such as the graphic designer Mirko Borsche and the graffiti icon Won ABC. Resolute criticism of media and the society, as in Tim Wolff's "Madness to Society," is a recurring topic at the Kirsch.

Schon optisch hebt sich das Kirsch & Co von klassischen Galerien ab: Es ist nicht klinisch weiß, sondern schwarz wie die Nacht und bietet Künstlern in Einzel- und Gruppenausstellungen eine multimediale Spielwiese mit viel Raum für Freiheit. Auch lokale Künstler mit internationaler Tragweite wie der Grafiker Mirko Borsche oder die Graffiti-Ikone Won ABC nutzen diese Nische. Inhaltlich begegnet man im Kirsch oft entschiedener Medien- und Sozialkritik wie bei Tim Wolffs „Madness to Society".

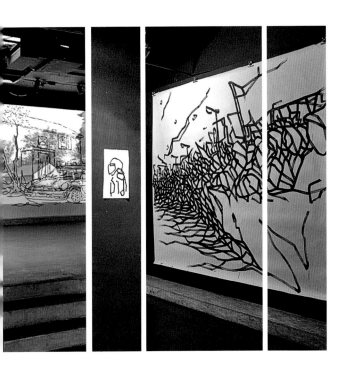

KIRSCH & CO

Herzog-Wilhelm-Straße 30 // Altstadt
Tel.: +49 (0)176 70863712
www.kirschundco.de

Wed–Sat 2 pm to 6 pm, Thu 2 pm to 8 pm
Vernissages and finissages 7 pm to 1 am
U1, U2, U3, U6, Tram 16, 17, 18, 27 Sendlinger Tor

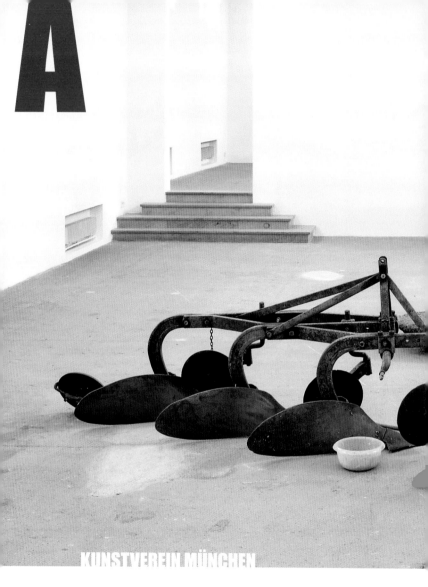

A

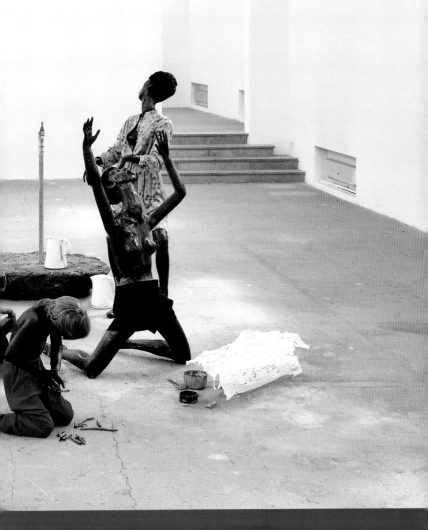

KUNSTVEREIN MÜNCHEN

Galeriestraße 4 // Altstadt
Tel.: +49 (0)89 22 11 52
www.kunstverein-muenchen.de

Tue–Sun 10 am to 6 pm
U3, U4, U5, U6 Odeonsplatz

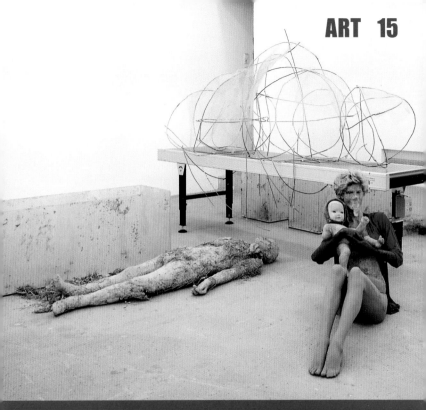

Located in the beautiful arcades of the Hofgarten, the Kunstverein has been a place for cultural exchange and discourse since its establishment in 1823. As a privately sponsored association, it is independent of political and economic influences. This autonomy allows for exhibitions that are both innovative and diverse, which in turn has attracted international attention and led to cooperations with distinguished institutions such as the Whitney Museum of American Art.

Seit seiner Gründung 1823 ist der in den schönen Arkaden des Hofgartens gelegene Kunstverein ein Ort des kulturellen Austauschs und des Diskurses. Sein Status als privat getragener Verein macht ihn unabhängig von politischen und wirtschaftlichen Interessen. Dieser Umstand zeigt sich in einer anregenden Themen- und Ausstellungsvielfalt, was wiederum für internationales Ansehen und Kooperationen mit hochkarätigen Institutionen wie dem Whitney Museum of American Art sorgt.

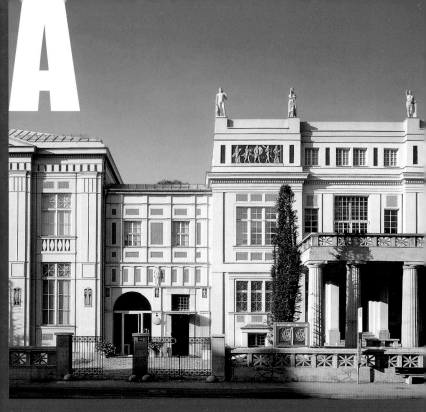

Franz von Stuck, painter, sculptor, and co-founder of the Munich Secession, commissioned this villa at the end of the 19th century based on his own designs. The master painter (the second to be called prince of painting after Franz von Lenbach) and admirer of Italy used the neoclassical Jugendstil villa as a studio and residence. Today, art and craft objects created and collected by von Stuck are shown in their original context in the lovingly restored, opulently furnished rooms.

Franz von Stuck, Maler, Bildhauer und Mitbegründer der Münchener Secession, ließ sich am Ende des 19. Jahrhunderts nach eigenen Entwürfen dieses Denkmal setzen. Der große Malerfürst (der zweite neben Franz von Lenbach) und Italienfreund nutzte die neoklassizistische Jugendstilvilla als Atelier und Wohngebäude. In den opulenten, liebevoll wiederhergestellten Räumen werden heute vom ihm geschaffene und gesammelte Kunsthandwerks- und Kunstobjekte im Originalkontext präsentiert.

VILLA STUCK

Prinzregentenstraße 60 // Bogenhausen
Tel.: +49 (0)89 4 55 55 10
www.villastuck.de

Tue–Sun 11 am to 6 pm
U4 Prinzregentenplatz
U5 Max-Weber-Platz
Bus 100, Tram 18 Friedensengel / Villa Stuck

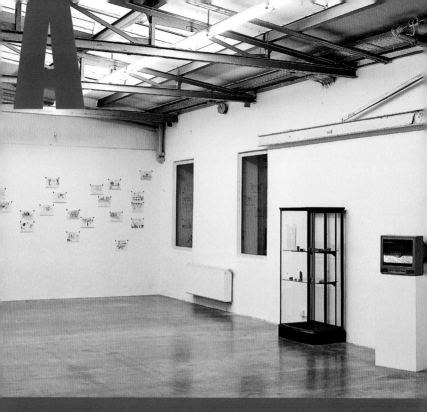

Lothringer13 is one of the liveliest spaces for contemporary art in Munich. Emerging artists, in particular, take advantage of the available production and presentation facilities. Since its inception, many renowned artists such as Louise Lawler, Fischli/Weiss, and Albert Oehlen have exhibited in the former machine factory. In addition to Lothringer13_Halle, the main exhibition space, Lothringer13 also encompasses Lothringer13_Laden, a gallery for media experiments.

Es ist eines der lebendigsten Zentren für Gegenwartskunst in München, das Lothringer13. Vor allem junge Künstler profitieren von den zur Verfügung stehenden Produktions- und Präsentationsmöglichkeiten. Im Laufe seines Bestehens waren viele renommierte Künstler wie Louise Lawler, Fischli/Weiss und Albert Oehlen in der ehemaligen Maschinenfabrik zu Gast. Neben der Lothringer13_Halle gehört der Lothringer13_Laden, Galerie und Ort für mediale Experimente, dazu.

LOTHRINGER13

Lothringer Straße 13 // Haidhausen
Tel.: +49 (0)89 4 48 69 61
www.lothringer13.de

Tue–Sun 11 am to 7 pm
S1–8, Tram 15, 25 Rosenheimer Platz
U5 Ostbahnhof

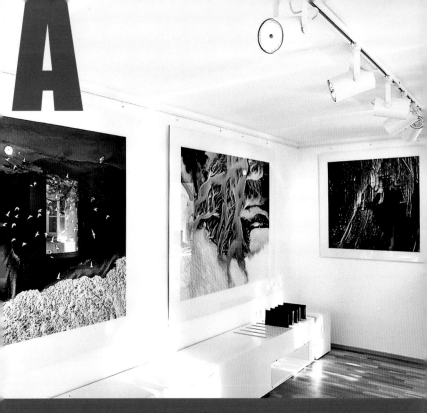

Patrick Löffler and Benjamin A. Monn have found a permanent home for their gallery project in the Glockenbachviertel. Their opening exhibition 2011 was an instant success: the distorted large-sized Polaroids ("Expired") of the Canadian photo artist Chad Coombs attracted a great deal of attention—and rightly so. The young gallery owners' goal is to promote and consult both budding artists and collectors.

Patrick Löffler und Benjamin A. Monn haben für ihr Galerieprojekt im Glockenbachviertel eine feste Heimat gefunden. Dort gelang ihnen 2011 mit der ersten Ausstellung gleich ein fulminanter Auftakt: Die verfremdeten großformatigen Polaroidaufnahmen („Expired") des kanadischen Fotokünstlers Chad Coombs erregten zu Recht Aufmerksamkeit. Das Ziel der jungen Galeristen ist die Förderung und Beratung von Nachwuchskünstlern und -sammlern.

CANDELA PROJECT GALLERY

Holzstraße 11 // Isarvorstadt
Tel.: +49 (0)89 23 88 67 60
www.candela-project.com

Tue–Fri 11 am to 6.30 pm
Sat 11 am to 3 pm
U1, U2, U3, U6, Tram 16, 17, 18, 27 Sendlinger Tor

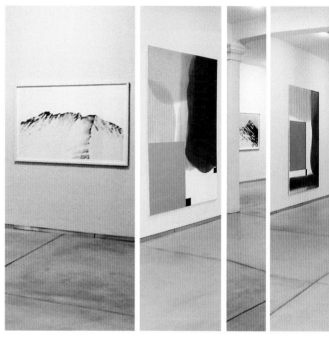

GALERIE WITTENBRINK

Jahnstraße 18 // Isarvorstadt
Tel.: +49 (0)89 2 60 55 80
www.galeriewittenbrink.de

Wed–Fri 2 pm to 6 pm
Sat 1 pm to 6 pm
U1, U2, U3, U6, Tram 16, 17, 18, 27 Sendlinger Tor

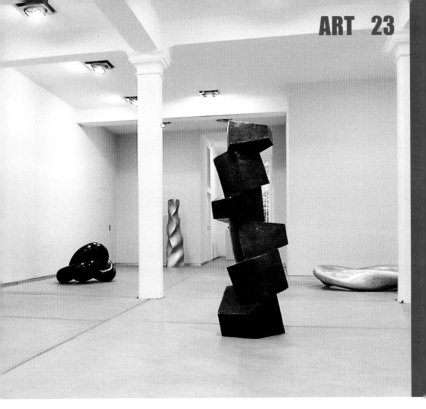

In 1984, Bernhard and Hanna Wittenbrink moved their gallery from Regensburg to Munich's Glockenbach district. Since 2003, they also operate a small branch in the Fünf Höfe shopping center. The Wittenbrinks are drawn to places where people congregate and want to be approachable to their audience. A visit to the generously sized main gallery is definitely recommended. In addition to paintings, sculptures, and media art, it also displays "art jewelry."

1984 zogen Bernhard und Hanna Wittenbrink mit ihrer in Regensburg gegründeten Galerie ins Münchner Glockenbachviertel. Seit 2003 sind sie mit einem kleinen Ableger auch in den Fünf Höfen vertreten. Die Wittenbrinks wollten dahin, wo Menschen sind, dem Publikum entgegenkommen. Ein Besuch in der großzügigen Zentrale empfiehlt sich trotzdem. Gezeigt wird neben Malerei, Skulptur und Medienkunst auch „Autorenschmuck".

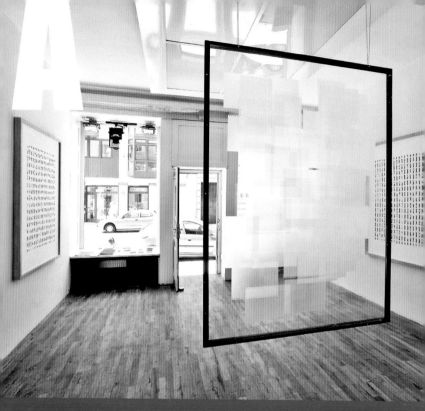

Weltraum (literally "outer space") is right here on earth and quite finite. This 650 sq. ft. gallery in Munich is powered solely by idealism and the love of art. Rudolf Maximilian Becker operates this unique independent outer space (he also lives there) without any commercial interest. Exhibitions change almost weekly—some of them even attract international attention, especially because Becker is extremely well networked and has many fans. Weltraum: may it live long and prosper!

Der Weltraum ist endlich – er misst 60 m² und befindet sich in München. Er speist sich lediglich aus Idealismus und der Liebe zur Kunst. Rudolf Maximilian Becker betreibt (und bewohnt) den einzigartigen, unabhängigen Projektraum ohne jegliches kommerzielles Interesse. Fast jede Woche gibt es eine neue Ausstellung, so manche erlangt sogar internationale Aufmerksamkeit. Auch, weil Becker extrem gut vernetzt ist und viele Fans hat. Lang lebe der Weltraum!

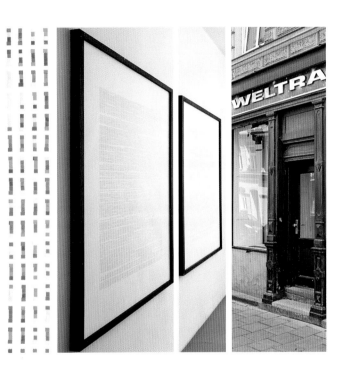

WELTRAUM

Rumfordstraße 26 // Isarvorstadt
Tel.: +49 (0)175 1 12 16 56
www.weltraum26.de

On appointment
Tram 17, 18 Reichenbachplatz

GALERIE REYGERS

Widenmayerstraße 49 // Lehel
Tel.: +49 (0)89 22 03 70
www.reygers.com

On appointment
Tram 17 Tivolistraße

ART 27

Hubertus Reygers calls his gallery a "general store," which is pure understatement paired with a touch of self-irony. But that is exactly what makes him—and the objects he hunts and collects—so unique: old watches, jewelry, exquisite cufflinks, Murano glass of the 1950s, propellers, a vintage travel bag by Hermès. This is complemented by temporary photo exhibitions.

Dass Hubertus Reygers sein Reich als „Gemischtwarenladen" bezeichnet, ist pures Understatement, mit einem Hauch Selbstironie. Und genau das zeichnet sowohl ihn selbst, als auch die von ihm gejagten und gesammelten Objekte aus: alte Armbanduhren, Schmuck, feinste Manschettenknöpfe, Murano-Glas der 1950er Jahre, Propeller, eine Vintage-Reisetasche von Hermès. Dazu gibt es wechselnde Fotoausstellungen.

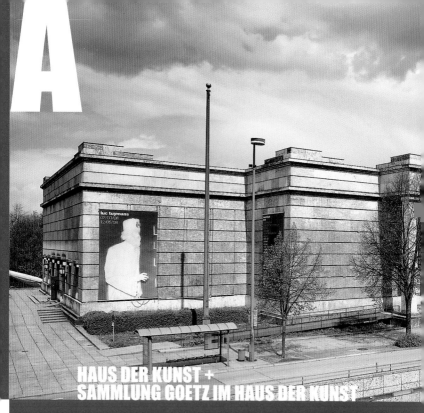

HAUS DER KUNST +
SAMMLUNG GOETZ IM HAUS DER KUNST

The neoclassical building adjoining the Englischer Garten was constructed at Hitler's behest and opened in 1937 as "Haus der Deutschen Kunst" (House of German Art). Today, the museum actively interprets its own history, especially since it began cataloging its historical archives. Temporary exhibitions set the stage for striking juxtapositions of contemporary art, design, fashion, dance, architecture, and other disciplines. Director Chris Dercon, who moved to Tate Modern in the spring of 2011, deserves much of the credit for these developments. The end of his tenure coincides with the Goetz Collection taking up residence in the former air-raid shelters in the basement, where works from Ingvild Goetz's extensive inventory of film and video art are being shown.

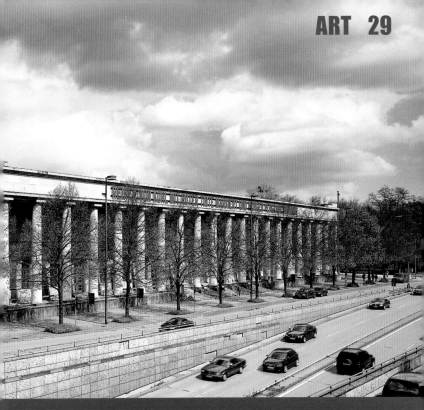

Der neoklassizistische Bau am Englischen Garten wurde auf Geheiß Hitlers gebaut und 1937 als Haus der Deutschen Kunst eröffnet. Heute setzt sich das Museum – insbesondere seit der Erschließung des hauseigenen Historischen Archivs – aktiv mit seiner Geschichte auseinander. Es treffen in wechselnden Ausstellungen zeitgenössische Kunst, Design, Mode, Tanz, Architektur und vieles mehr beispielhaft aufeinander. Der im Frühjahr 2011 zur Tate Modern gewechselte Direktor Chris Dercon hat einen großen Anteil an diesen Entwicklungen. Das Ende seiner Amtszeit fällt zusammen mit dem Einzug der Sammlung Goetz in die ehemaligen Luftschutzkeller des Hauses, wo Werke aus Ingvild Goetz' umfangreichem Bestand an Film- und Video-Kunst gezeigt werden.

HAUS DER KUNST

Prinzregentenstraße 1 // Lehel
Tel.: +49 (0)89 21 12 71 13
www.hausderkunst.de

Mon–Sun 10 am to 8 pm
Thu 10 am to 10 pm
Bus 100 Königinstraße, Tram 17 Nationalmuseum / Haus der Kunst

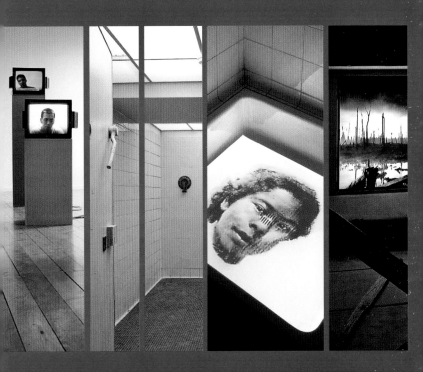

SAMMLUNG GOETZ IM HAUS DER KUNST

Prinzregentenstraße 1 // Lehel
Tel.: +49 (0)89 21 12 71 13
www.hausderkunst.de

Fri–Sun 10 am to 8 pm
Bus 100 Königinstraße
Tram 17 Nationalmuseum / Haus der Kunst

INGVILD GOETZ

"I'm not interested in pretty pictures," says Ingvild Goetz, a collector of non-conformist art since the 1970s. Thanks to her instincts and her own non-conformity, she has set herself apart from others in the art market, and presently has one of the largest and most exciting private collections of contemporary art in the world. Her collection is open to the public free of charge in a building designed by Herzog and de Meuron which was completed in 1993. Goetz enjoys allowing the public to interact with the predominantly socio-critical works. Yet her collection revolves around more than political issues; everyday life is a recurrent theme as well. For instance, Ingvild Goetz has worked with Swiss artists Peter Fischli and David Weiss for over thirty years. She has discovered many artists whose names have become well-known as well as big artists who have stayed small. When purchasing art, Ingvild Goetz looks beyond a potential return on investment: she buys out of conviction.

„Ein schönes Bild interessiert mich nicht", sagt Ingvild Goetz, die seit den 1970er Jahren unangepasste Kunst sammelt. Dank ihres inneren Kompasses und ihrer eigenen Unangepasstheit, mit der sie sich in vielerlei Hinsicht von anderen Akteuren auf dem Kunstmarkt absetzt, verfügt sie vier Jahrzehnte später über eine der größten und spannendsten Privatsammlungen für zeitgenössische Kunst weltweit. Die macht sie in ihrem 1993 fertiggestellten Haus von Herzog & de Meuron kostenlos der Öffentlichkeit zugänglich. Es ist der Hausherrin ein Anliegen, das Publikum mit den zum großen Teil sozialkritischen Arbeiten interagieren zu lassen. Aber nicht nur das Politische, auch das Alltägliche ist ein wiederkehrendes Thema der Sammlung: Die Schweizer Peter Fischli und David Weiss zum Beispiel begleitet Ingvild Goetz schon seit über dreißig Jahren. Viele Künstler hat sie entdeckt, deren Namen bald groß wurden, aber auch große Künstler, die klein blieben. Ingvild Goetz kauft eben nicht im Hinblick auf die potenzielle Rendite, sondern aus Überzeugung.

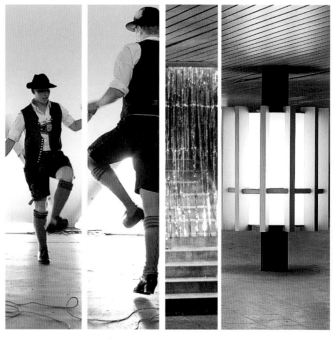

MAXIMILIANSFORUM

Maximilianstraße 38 (Passage Maximilianstraße / Altstadtring) // Lehel
www.maximiliansforum.de

24 hours daily
Tram 19 Kammerspiele
Tram 17 Maxmonument

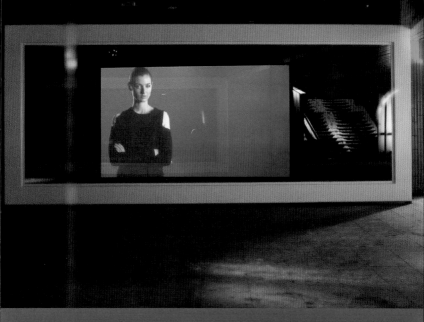

Munich's most exciting underground exhibition space—the Arcade for Interdisciplinary Art—shows multimedia works by free-thinking and creative artists such as Ayzit Bostan, Pollyester, Florian Süssmayr, and Mirko Borsche. It's open 24 hours a day and admission is free. The 17,000 sq. ft. pedestrian underpass under the intersection of Altstadtring and Maximilianstraße is an open, yet protected area and provides space for experimental ideas right in the heart of the city.

Münchens spannendster Ausstellungsort im Untergrund, die Passage für interdisziplinäre Kunst, wird von querdenkenden Kulturschaffenden und Künstlern wie Ayzit Bostan, Pollyester, Florian Süssmayr oder Mirko Borsche multimedial bespielt und ist jederzeit kostenfrei zugänglich. Die ca. 1 600 m² große Unterführung unter der Kreuzung von Altstadtring und Maximilianstraße, ein offener und doch geschützter Bereich, fungiert als Raum für experimentelle Ideen mitten in der Stadt.

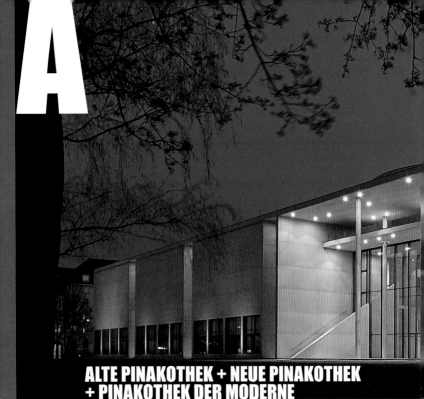

ALTE PINAKOTHEK + NEUE PINAKOTHEK + PINAKOTHEK DER MODERNE

Opened in 1836, the Alte Pinakothek encompasses the collections amassed by the Wittelsbach dynasty and includes masterpieces of European painting from the Middle Ages to the 18th century. Continuing where the Alte Pinakothek leaves off, the Neue Pinakothek is considered one of the world's most important galleries of 19th century art. Designed by Stephan Braunfels, the Pinakothek der Moderne unifies four independent museums: the National Collection of Modern and Contemporary Arts, the National Collection of Works on Paper, the New Collection, and the Technical University of Munich's Museum of Architecture.

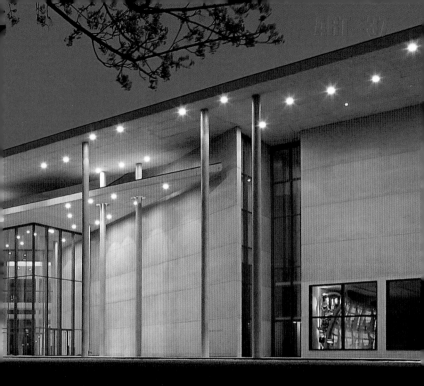

Die bereits 1836 eröffnete Alte Pinakothek geht auf die Sammelleidenschaft der Wittelsbacher Dynastie zurück und vereint die großen Meisterwerke der europäischen Malerei vom Mittelalter bis ins 18. Jahrhundert. Die Neue Pinakothek knüpft zeitlich da an und gilt weltweit als eine der wichtigsten Gemäldegalerien für die Kunst des 19. Jahrhunderts. Die nach einem Entwurf von Stephan Braunfels gebaute Pinakothek der Moderne umfasst vier eigenständige Museen: die Sammlung Moderne Kunst, die Staatliche Graphische Sammlung, die Neue Sammlung und das Architekturmuseum der Technischen Universität.

PINAKOTHEK DER MODERNE

Barer Straße 40 // Maxvorstadt
Tel.: +49 (0)89 23 80 53 60
www.pinakothek.de

Tue–Sun 10 am to 6 pm
Thu 10 am to 8 pm
U2 Theresienstraße, U3, U4, U5, U6 Odeonsplatz
Bus 100, Tram 27 Pinakotheken

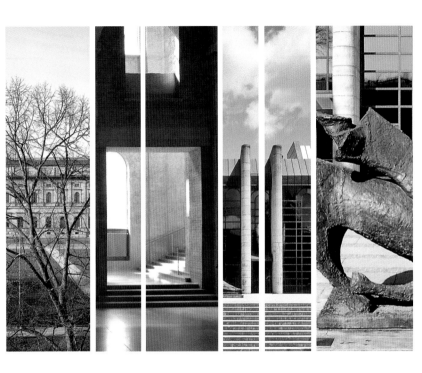

ALTE PINAKOTHEK

Barer Straße 27 // Maxvorstadt
Tel.: +49 (0)89 23 80 52 16
www.pinakothek.de

Tue 10 am to 8 pm, Wed–Sun 10 am to 6 pm
U2 Theresienstraße,
U3, U4, U5, U6 Odeonsplatz
Bus 100, Tram 27 Pinakotheken

NEUE PINAKOTHEK

Barer Straße 29 // Maxvorstadt
Tel.: +49 (0)89 23 80 51 95
www.pinakothek.de

Thu–Mon 10 am to 6 pm, Wed 10 am to 8 pm
U2 Theresienstraße,
U3, U4, U5, U6 Odeonsplatz
Bus 100, Tram 27 Pinakotheken

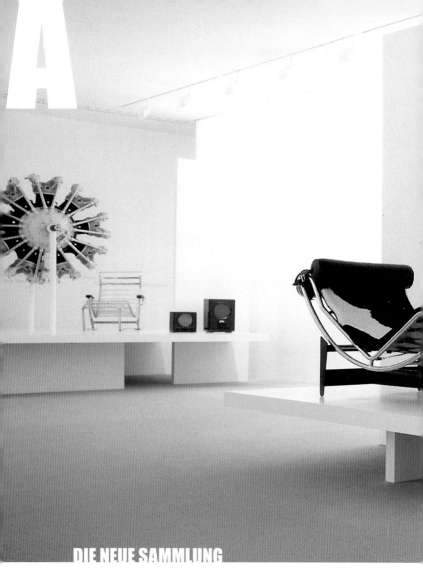

A

DIE NEUE SAMMLUNG

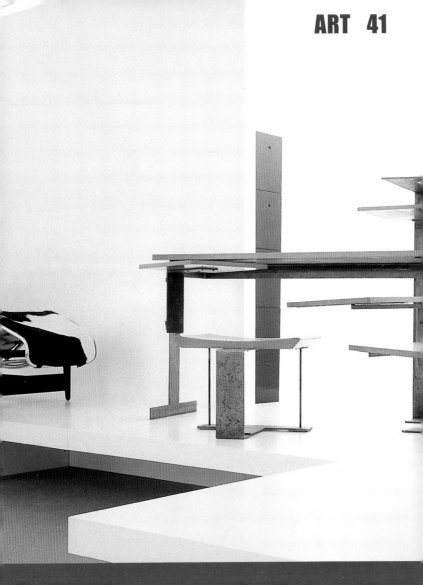

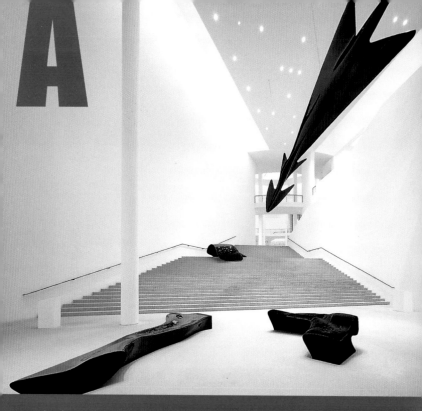

It has been around much longer than the Pinakothek der Moderne itself—longer even than the word "design" in its current meaning. As early as 1907, "modern examples" of everyday objects were being collected. These still form the core of the collection, which became a state institution in 1925. The permanent inventory now includes about 80,000 objects from industrial and graphic design as well as arts and crafts. The immense spectrum is rounded out by interdisciplinary exhibitions.

Es gibt sie schon viel länger als die Pinakothek der Moderne selbst. Und viel länger als das Wort „Design" im heutigen Sinne. Schon um 1907 begann man, „moderne Vorbilder" unter den Dingen des alltäglichen Gebrauchs zu sammeln, die auch heute noch den Kern der 1925 zur Staatsinstitution beförderten Sammlung darstellen. Mittlerweile zählen ca. 80 000 Objekte aus Industrie-, Grafikdesign und angewandter Kunst zum festen Bestand. Interdisziplinäre Sonderausstellungen runden das immense Spektrum ab.

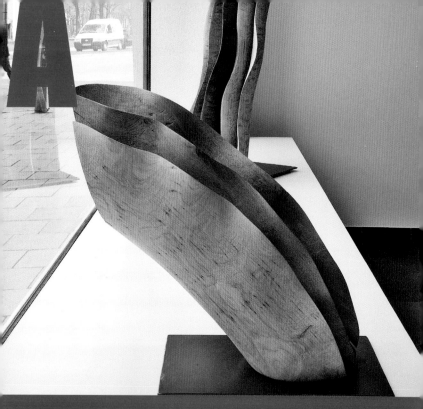

Owner Barbara Ruetz has a focused and solid concept: she presents international contemporary art by artists who have already made a name for themselves in their home countries but whose big breakthrough is yet to happen. The exhibitions change every eight weeks, usually encompassing paintings and sculptures that enter into a dialog with each other—and the Pinakothek complex across the street. The result is a juxtaposition of exciting new discoveries and works that have stood the test of time.

Das Konzept der Galeristin Barbara Ruetz ist klar und kraftvoll: Sie zeigt internationale Gegenwartskunst von Künstlern, die sich in ihren Heimatländern schon einen Namen gemacht haben, denen der große Durchbruch aber noch bevorsteht. Alle acht Wochen wechselt das Programm in den zwei Bereichen der Galerie. Zumeist sind es Malerei und Skulptur, die miteinander – und mit dem gegenüberliegenden Pinakothekenareal – in den Dialog treten. So verbinden sich aufregende Neuentdeckungen mit Altbewährtem.

GALERIE AN DER PINAKOTHEK DER MODERNE – BARBARA RUETZ

Gabelsbergerstraße 7 // Maxvorstadt
Tel.: +49 (0)89 28 80 77 43
www.galerie-ruetz.de

Mon on appointment
Tue–Fri noon to 7 pm, Sat noon to 6 pm
Sun noon to 6 pm (no sales)
Tram 27 Karolinenplatz

GALERIE RÜDIGER SCHÖTTLE

Amalienstraße 41 // Maxvorstadt
Tel.: +49 (0)89 33 36 86
www.galerie-ruediger-schoettle.de

Tue–Fri 11 am to 6 pm
Sat noon to 4 pm
U3, U6 Universität

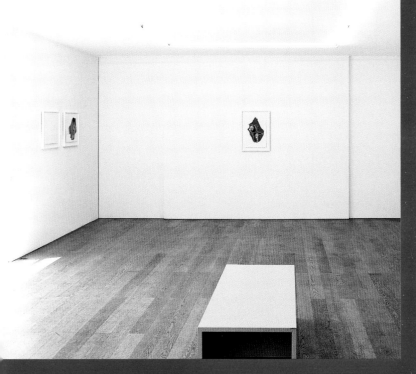

Rüdiger Schöttle was the first to introduce many renowned artists to the German market, including Jenny Holzer, Dan Graham, Jeff Wall, Andreas Gursky, and Thomas Ruff. He also represents Munich painter Florian Süssmayr, whose work has attracted a great deal of attention. The attractive gallery has been an important forum for contemporary art since it opened its doors in 1968. Schöttle's book "Bestiary of Art" inspired the Haus der Kunst to put on an eponymous exhibition.

Viele bedeutende Künstler wurden in Deutschland das erste Mal durch Rüdiger Schöttle präsentiert, so Jenny Holzer, Dan Graham, Jeff Wall, Andreas Gursky oder Thomas Ruff. Auch der vielbeachtete Münchner Maler Florian Süssmayr wird von Schöttle vertreten. Seit ihrer Gründung 1968 fungiert die Galerie als Forum für zeitgenössische Kunst. Schöttles Buch „Bestiarum der Kunst" inspirierte das Haus der Kunst zur gleichnamigen Ausstellung.

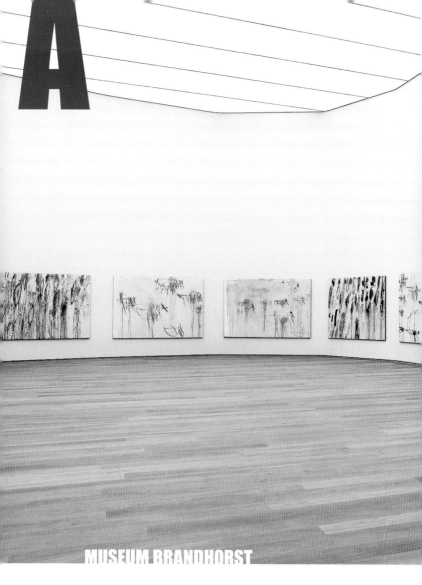

A

MUSEUM BRANDHORST

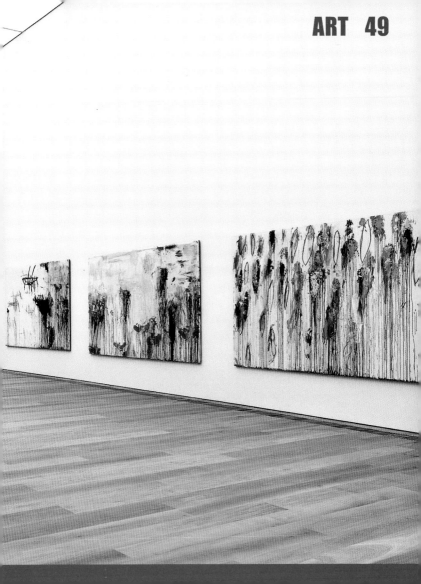

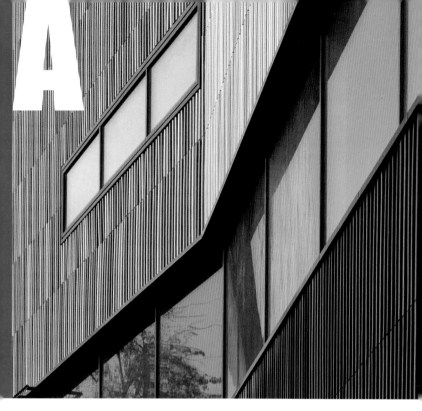

36,000 ceramic rods spanning no less than 23 colors make up the facade of this recently inaugurated museum, giving it a vibrant, iridescent, and flickering appearance. While all the vast rooms are kept in white, the exhibits are as colorful as the exterior. The collection was assembled by the married couple Brandhorst and features some of the most influential artists of the late 20th century, including Andy Warhol, Joseph Beuys, and Damien Hirst, while a whole floor is dedicated to Cy Twombly.

36 000 Keramikstäbchen in 23 Farben bilden die Fassade dieses kürzlich eröffneten Museums und verleihen ihm ein schillerndes, knallbuntes Äußeres. Während die kolossalen Innenräume durchgehend in Weiß gehalten sind, geben sich die Exponate ähnlich farbenfroh wie die Verschalung. Die vom Ehepaar Brandhorst zusammengestellte Sammlung umfasst einige der einflussreichsten Künstler des späten 20. Jahrhunderts, darunter Andy Warhol, Joseph Beuys und Damien Hirst. Eine ganze Etage ist Cy Twombly gewidmet.

MUSEUM BRANDHORST

Theresienstraße 35a // Maxvorstadt
Tel.: +49 (0)89 2 38 05 22 86
www.museum-brandhorst.de

Tue–Sun 10 am to 6 pm, Thu 10 am to 8 pm
U3, U6 Universität, U2 Theresienstraße
Bus 100, Tram 27 Pinakotheken

WANDERGALERIE
STEPHANIE BENDER

Schleißheimer Straße 9 // Maxvorstadt
Tel.: +49 (0)89 30 70 46 06
www.stephaniebender.de

Wed–Fri 3 pm to 6 pm, Sat noon to 3 pm
Tram 20, 21 Stiglmaierplatz
U2 Königsplatz

Before Stephanie Bender moved her gallery to a permanent home in 2008, she spent two years wandering from one unconventional location to another, showing art in places that, according to her, were the "opposite of white cubes." Mira Thomsen's disturbing collages, for example, were shown in the catacombs below the Isartor. Even though she has settled down, Bender still challenges her audience with works by artists like Carlos De los Rios.

Bevor Stephanie Bender mit ihrer Galerie 2008 sesshaft wurde, zog sie zwei Jahre lang von einer Off-Location zur nächsten und zeigte Kunst an Orten, die, wie sie sagt, das „Gegenteil von weißen Kuben" sind. Mira Thomsens beunruhigende Kollagen beispielsweise wurden in den Katakomben unter dem Isartor inszeniert. Die inzwischen angekommene Galeristin hält mit Künstlern wie Carlos De los Rios ihr Publikum aber immer noch bestens auf Trab.

ECTURE

Munich natives are well aware of their architectural heritage—painful as it is at times. It includes the magnificent Wittelsbach-era buildings (the Residenz Palace in particular), the Art Nouveau buildings in Schwabing, various city mansions, and the classical buildings surrounding the Königsplatz. Yet Munich also has an architectonic legacy from the Nazis, who abused Munich's spectacular backdrop for their own reprehensible purposes. After World War II, most of the city center lay in ruins—but Munich residents rebuilt with an eye to restoring the historic character. Even today, new buildings are still regarded with suspicion: in the 1980s, the blueprints for the Staatskanzlei ("State Chancellery") caused a scandal, petitions resulted in high-rise buildings being banned from the city center, and even the world famous tent-like Olympic Stadium—a revolutionary design by Frei Otto and Günter Behnisch—was accepted only gradually. But if the new fits in with the old, that's considered fine, as is the case with the impressive Jewish Center on Jakobsplatz.

Die Münchner sind sich ihres architektonischen Erbes (teilweise schmerzhaft) bewusst. Da sind zum einen die Prachtbauten der Wittelsbacher, allen voran die Residenz, der Schwabinger Jugendstil, die Stadtvillen und die Bauten des Klassizismus, der sich am Königsplatz in seiner ganzen Pracht entfaltet. Zum anderen sind da die baulichen Hinterlassenschaften der Nazis, die die herrschaftliche Kulisse Münchens aufs Sträflichste instrumentalisierten. Nach dem Zweiten Weltkrieg lag ein Großteil der Innenstadt in Trümmern – doch man baute historisch erhaltend wieder auf. Bis heute erzeugen Neubauten Argwohn: Der Bauplan der Staatskanzlei löste in den 1980er Jahren einen handfesten Skandal aus, potenzielle Hochhäuser wurden per Bürgerbegehren aus dem inneren Stadtgebiet verbannt, und sogar die weltberühmte Zeltkonstruktion des Olympiastadions, eine Meisterleistung von Frei Otto und Günter Behnisch, fand erst allmählich Anklang. Aber wenn das Neue zum Alten passt, dann passt es. So wie das beeindruckende Jüdische Zentrum am Jakobsplatz.

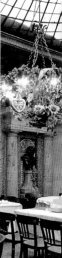

AUGUSTINERBRÄU

Neuhauser Straße 27 // Altstadt
Tel.: +49 (0)89 23 18 32 57
www.augustiner-restaurant.com

Mon–Sun 10 am to midnight
S1–8, U4, U5 Karlsplatz (Stachus), U3, U6 Marienplatz

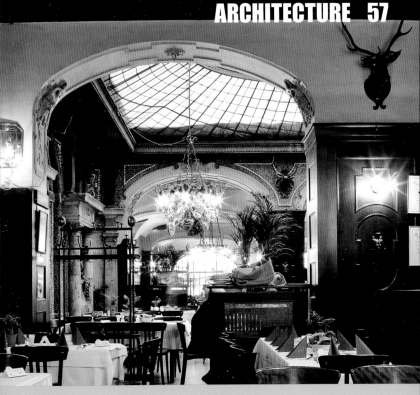

It would be easy to mistake the Augustiner brewery on Neuhauser Straße for a tourist trap and hence avoid it altogether. That would be a pity because it is the last real "beer palace" from the reign of Prince Luitpold. Not only does it serve excellent beer, its building is remarkable as well. Particularly beautiful: the Shell Hall with its impressive dome of iron and glass, decorative busts, antlers, columns, stucco, and intricate ornaments made of real shells and pebbles.

Man könnte das in der Neuhauser Straße gelegene Augustinerbräu leicht als Touristenfalle missverstehen und möglicherweise meiden. Das wäre schade, denn der letzte richtige „Bierpalast" aus der Prinzregentenzeit schenkt nicht nur gutes Bier aus. Besonders schön ist der Muschelsaal mit der imposanten Kuppelkonstruktion aus Eisen und Glas und den schmückenden Büsten, Geweihen, Säulen, dem Stuck und natürlich den kunstvollen Ornamenten aus echten Muscheln und Kieselsteinen.

A

FÜNF HÖFE

Opened in 2003, Fünf Höfe ("Five Courtyards") is a spacious and stylish shopping arcade and cultural space at a historic location between Theatinerstraße and Kardinal-Faulhaber-Straße. It was designed by Herzog & de Meuron, who reserved a lot of room for public art, including Olafur Eliasson's "Sphere" in Viscardihof and Tita Giese's "Hanging Gardens" in Salvatorpassage. In addition, Fünf Höfe is home to Hypo-Kunsthalle and its first-rate exhibition program.

Seit 2003 hat München an historischer Stelle, zwischen Theatiner- und Kardinal-Faulhaber-Straße, einen verzweigten Shopping- und Kulturtempel. Gebaut wurde diese innerstädtische Passage von Herzog & de Meuron, die viel Platz geschaffen haben für öffentliche Kunst: für Olafur Eliassons Spiral-kugel „Sphere" im Viscardihof oder für die „Hängenden Gärten" von Tita Giese in der Salvatorpassage. Auch die Hypo-Kunsthalle ist hier zu Hause und mit ihr ein erstklassiges Ausstellungsprogramm.

FÜNF HÖFE

Kardinal-Faulhaber-Straße 10 // Altstadt
Tel.: +49 (0)89 24 44 95 80
www.fuenfhoefe.de

Mon–Sun until about 8 pm
S1–8 Marienplatz
U3, U4, U5, U6 Odeonsplatz

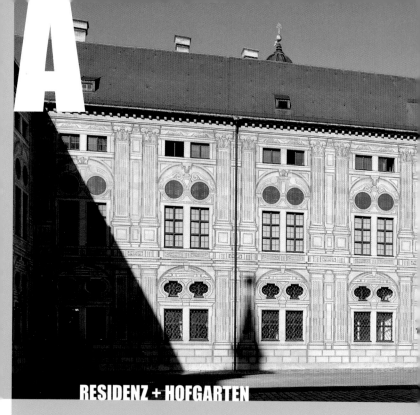

RESIDENZ + HOFGARTEN

The Residenz was constructed over the course of 500 years, combining stylistic influences from the Renaissance, Baroque, Rococo, and Classicism, and is the largest city palace in Germany. From the early 16th century until the end of WW I, it served as the residence and seat of government of the Bavarian rulers who amassed large collections of fine and decorative art. Today, these treasures can be seen in the Residenz Museum, the Treasury, and the Porcelain Cabinet. Other highlights include the Antiquarium, the most lavish Renaissance hall this side of the Alps; the Cuvilliés Theater; the King's Tract by Leo von Klenze; the Fountain Court; and the State Collection of Ancient Egyptian Art. The idyllic Hofgarten was developed in 1613 under Elector Maximilian I and was later expanded and redesigned multiple times. Today, it is the site of an annual boules tournament. The Pavilion, the centerpiece of the garden, is a favorite spot for musicians, dancers, and lovers.

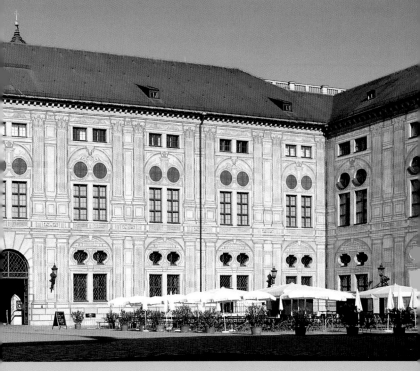

Die Residenz, das größte innerstädtische Schloss Deutschlands, entstand über einen Zeitraum von 500 Jahren. Sie vereint stilistische Einflüsse aus Renaissance, Barock, Rokoko und Klassizismus. Vom frühen 16. Jahrhundert bis zum Ende des Ersten Weltkrieges war die Residenz Wohn- und Regierungssitz der bayerischen Herrscher und damit ein Ort, an dem Kunst und Kunsthandwerk gesammelt wurde. Unter anderem kann man diese Schätze im Residenzmuseum, der Schatzkammer und im Porzellankabinett bewundern. Weitere Höhepunkte sind das Antiquarium, der prächtigste Renaissance-Saal diesseits der Alpen, das Cuvilliés-Theater, der Königsbau von Leo von Klenze, der Brunnenhof und die Staatliche Sammlung Ägyptischer Kunst. Der idyllische Hofgarten wurde ab 1613 unter Kurfürst Maximilian I. angelegt und im Laufe der Zeit mehrfach erweitert und umgestaltet. Ein Mal im Jahr findet hier ein Boule-Turnier statt, viel öfter finden sich Musiker, Tänzer und verliebte Pärchen im Pavillon ein, dem Herzstück des Gartens.

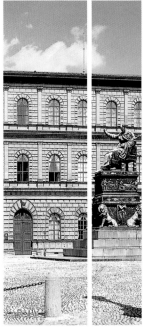

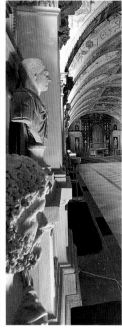

RESIDENZ

Residenzstraße 1 // Altstadt
Tel.: +49 (0)89 29 06 71
www.residenz-muenchen.de

Residenzmuseum Apr until mid Oct 9 am to 6 pm,
Mid Oct until end of Mar 10 am to 5 pm
S1–8, U3, U6 Marienplatz or U3, U4, U5, U6 Odeonsplatz

HOFGARTEN

Odeonsplatz // Altstadt
www.residenz-muenchen.de

U3, U4, U5, U6 Odeonsplatz

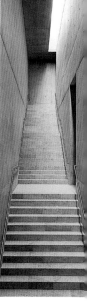

JÜDISCHES MUSEUM MÜNCHEN

St.-Jakobs-Platz 16 // Altstadt
Tel.: +49 (0)89 23 39 60 96
www.juedisches-museum-muenchen.de
www.ikg-muenchen.de

Museum Tue–Sun 10 am to 6 pm
U1, U2, U3, U6, Tram 16, 17, 18, 27 Sendlinger Tor
S1–8 Marienplatz

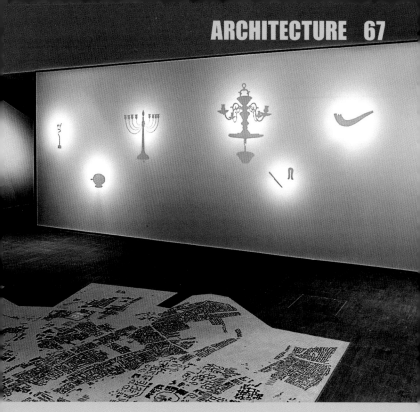

Long overdue, the Jewish Center on Jakobsplatz is a blessing, not just for the community but also for urban development. Three impressive new buildings were constructed based on designs by Wandel Hoefer Lorch: the centerpiece is the new main synagogue whose monolithic base and three-tiered tent roof express stability and fragility. Below ground, the "Tunnel of Rememberance" connects the synagogue to the community center; the Jewish Museum serves as the architectural link between both.

Das längst überfällige Jüdische Zentrum am Jakobsplatz ist auch in städtebaulicher Hinsicht ein Segen. Nach den Plänen des Büros Wandel Hoefer Lorch entstanden drei eindrucksvolle Neubauten: Das Herzstück ist die Neue Hauptsynagoge, die durch ihren monolithischen Sockel und das dreischichtige Zeltdach Stabilität und Fragilität vereint. Der „Gang der Erinnerung" verbindet die Synagoge unterirdisch mit dem Gemeindehaus; das Jüdische Museum ist das architektonische Bindeglied zwischen beiden.

Mehr Erotik, bitte!

LITERATURHAUS

Salvatorplatz 1 // Altstadt
Tel.: +49 (0)89 2 91 93 40
www.literaturhaus-muenchen.de

Check website for current events
U3, U4, U5, U6 Odeonsplatz

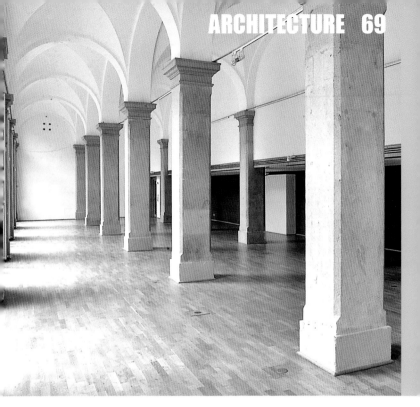

Thomas Mann, erstwhile resident of Munich and "household god," would have loved it: the view of the Theatine Church and the city lights from the top floor of the Literaturhaus is stunning. The harmonious conversion of this neorenaissance building by Munich-based architects Kiessler + Partner is award-winning, and thanks to an airy steel-and-glass construction, the building now has its top floor back. Don't miss the details, such as Jenny Holzer's digital installation in the café that pays homage to Oskar Maria Graf.

Das hätte auch Thomas Mann, dem Wahlmünchner und „Hausgott", gefallen: Vom oberen Stockwerk des Literaturhauses offenbart sich ein einmaliger Blick auf die Theatinerkirche und die „leuchtende" Stadt. Der stimmige Umbau des Neorenaissance-Gebäudes durch das Münchner Büro Kiessler + Partner ist preisgekrönt und hat dem Gebäude mit einer filigranen Stahl-Glas-Konstruktion das Dachgeschoss wiedergegeben. Man beachte aber auch die Details wie die digitale Installation von Jenny Holzer als Hommage an Oskar Maria Graf im Café.

MÜNCHNER KAMMERSPIELE

Falckenbergstraße 2 // Altstadt
Tel.: +49 (0)89 23 39 66 00
www.muenchner-kammerspiele.de

Check website for current events
Tram 19 Kammerspiele

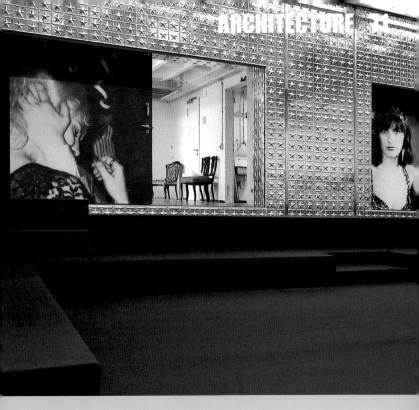

Its repertoire—and its use and interpretation of "space"—make the Kammerspiele one of Germany's most exciting theaters. In addition to the main stage—the hidden Jugendstil theater without a facade—the complex designed by Bert Neumann includes several smaller venues: the experimental stage in the Neues Haus which has been converted into the "Spielhalle," the "Werkraum," where actors and the audience meet at eye level like in a walk-in mirror ball, and the urban space.

Ihr Repertoire, aber auch die Nutzung und die Interpretation von „Raum" machen die Kammerspiele zu einer der spannendsten Bühnen Deutschlands. Zu den von Bert Neumann gestalteten Spielstätten gehören neben der Hauptbühne – dem versteckten Jugendstiltheater ohne Fassade – die zur „Spielhalle" umgebaute Probebühne im Neuen Haus, der Werkraum, in dem sich Schauspieler und Publikum wie in einer begehbaren Diskokugel auf Augenhöhe begegnen, und wortwörtlich der „Stadtraum" München.

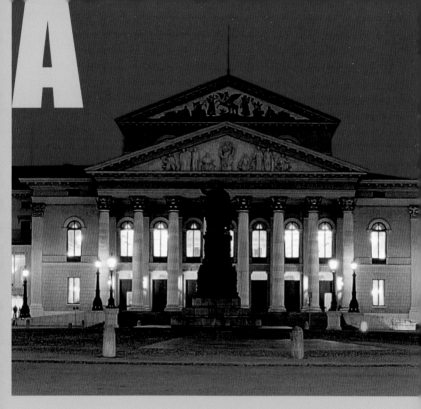

A

Designed by Karl von Fischer and built between 1811 and 1818, the Royal Court and National Theater was commissioned by King Maximilian I Joseph. Even though he envisioned it as a venue for all social classes, the architecture reminiscent of a Greek temple is distinctly feudal. Severely damaged twice by fire and almost completely destroyed in WW II, the magnificent theater is one of the world's leading opera houses and home to the Bavarian State Ballet.

Das nach Plänen Karl von Fischers zwischen 1811 und 1818 gebaute Königliche Hof- und Nationaltheater sollte nach dem Willen seines Bauherren König Maximilian I. Joseph von allen Gesellschaftsschichten besucht werden. Dennoch ist die an einen griechischen Tempel erinnernde Optik höchst feudal. Zwei Mal durch Brände schwer beschädigt und im Zweiten Weltkrieg fast vollständig zerstört, ist das prachtvolle Theater eines der führenden Opernhäuser weltweit – und Spielstätte des Staatsballetts.

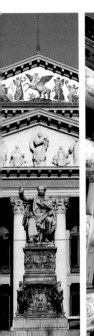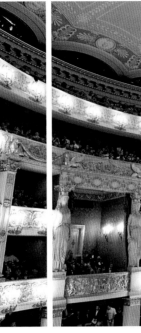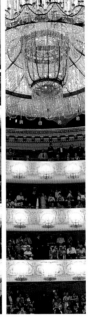

NATIONALTHEATER

Max-Joseph-Platz 2 // Altstadt
Tel.: +49 (0)89 21 85 01
www.bayerische.staatsoper.de

Check website for current events
S1–8, U3, U6 Marienplatz, U4, U5 Odeonsplatz
Tram 19 Nationaltheater

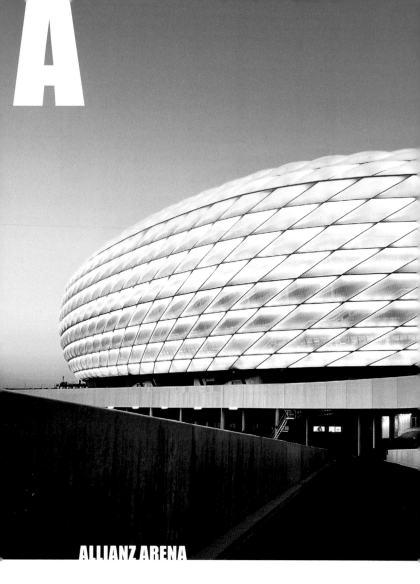

A

ALLIANZ ARENA

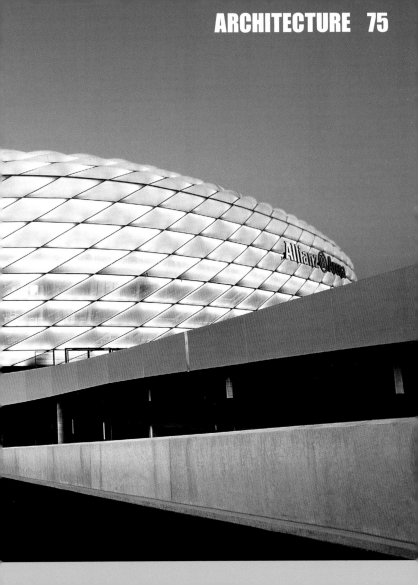

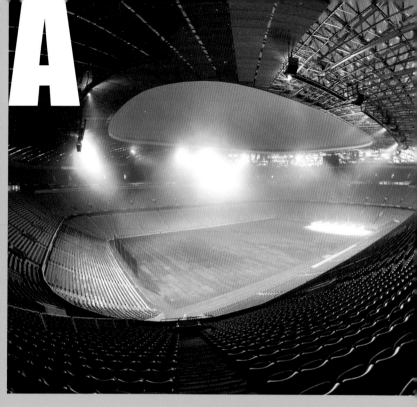

A

The famous "inflatable boat" in Fröttmaning was built in just three years based on a design by Herzog & de Meuron. It is home to two soccer clubs: FC Bayern Munich and TSV 1860 Munich. Its membrane shell consisting of 2,760 white, red, and blue air cushions that can be illuminated is the largest of its kind in the world. Seven levels provide covered seating for 69,901 spectators and house restaurants, the FC Bayern Megastore, two daycare centers, and LEGO World.

Das berühmte „Schlauchboot" in Fröttmaning, Spielstätte des FC Bayern und des TSV 1860 München, entstand nach einem Entwurf von Herzog & de Meuron in nur drei Jahren Bauzeit. Seine aus 2 760 weiß, rot und blau beleuchtbaren Luftkissen bestehende Membranhülle ist die weltweit größte ihrer Art. Auf sieben Ebenen sind 69 901 überdachte Sitzplätze, Gastronomiebetriebe, der „Megastore" des FC Bayern und sogar zwei Kitas und eine LEGO-Welt untergebracht.

ALLIANZ ARENA

Werner-Heisenberg-Allee 25 // Fröttmaning
Tel.: +49 (0)89 2 00 50
www.allianz-arena.de

Check website for events and to register for guided tours
U6 Fröttmaning

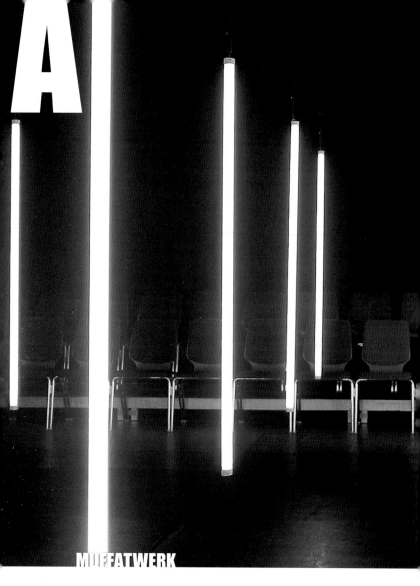

A

MUFFATWERK

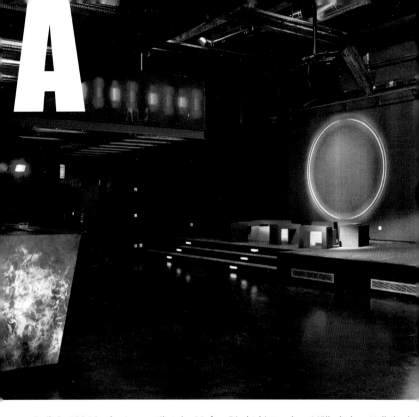

Built in 1894 in the Jugenstil style, Muffathalle is located right behind Müller'sches Volksbad. The former steam-heating power plant with its highly visible smokestack is a protected monument. Since its renovation in 1992, it has been Munich's most important cultural center. In the hall, café, beer garden, and Ampere Club, visitors find a richly varied program beyond the cultural mainstream, presented in a uniquely beautiful and very relaxing green setting.

Direkt hinter dem Müller'schen Volksbad liegt die 1894 im Jugendstil erbaute Muffathalle. Das ehemalige Dampfheizkraftwerk, mit seinem weithin sichtbaren Schornstein, steht unter Denkmalschutz und ist seit seiner Sanierung 1992 Münchens wichtigstes Kulturzentrum. In der Halle, dem Café, Biergarten und im Ampere Club wird dem Besucher ein abwechslungsreiches Programm jenseits vom kulturellen Einheitsbrei geboten – in einmalig schöner und dazu noch entspannend grüner Kulisse.

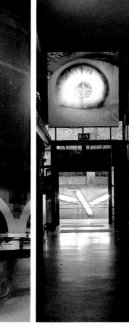

MUFFATWERK

Zellstraße 4 // Haidhausen
Tel.: +49 (0)89 45 87 50 10
www.muffathalle.de

Check website for current events
S1–8 Isartor or Rosenheimer Platz
Tram 18 Deutsches Museum

A

MÜLLER'SCHES VOLKSBAD

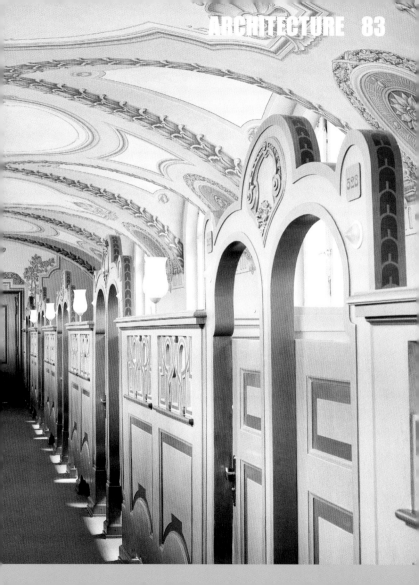

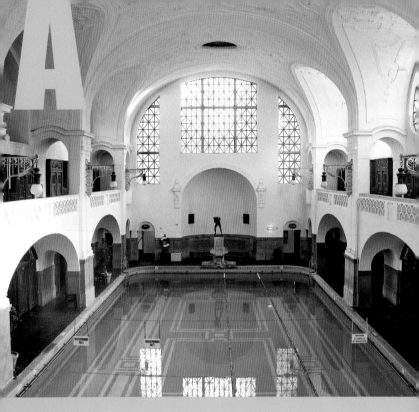

When it opened in 1901, this Jugendstil public bath designed by Carl Hocheder was the most modern and luxurious facility of its kind in Europe. Wealthy building contractor Karl Müller intended it to be a gift to "people without means" who would be able to enjoy the Roman-Irish steam bath and the two beautiful indoor pools. Richly decorated with many bronze figurines, murals, and neobaroque elements, the Volksbad continues to be a precious gift.

Bei seiner Fertigstellung im Jahre 1901 war das von Carl Hocheder entworfene Jugendstil-Bad das modernste und luxuriöseste seiner Art in Europa. Dabei hatte sein Stifter, der wohlhabende Bauunternehmer Müller, vor allem das „unbemittelte Volk" im Sinn, dem er mit dem römisch-irischen Schwitzbad und den zwei wunderschönen Schwimmhallen etwas Gutes tun wollte. Bis heute ist die mit vielen Bronzefiguren, Wandmalereien und neobarocken Elementen verzierte Anlage ein kostbares Geschenk.

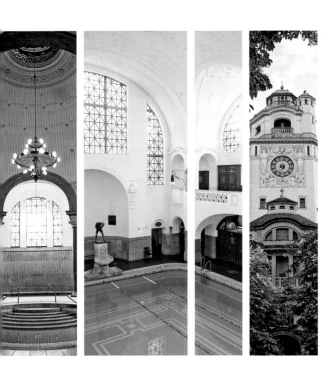

MÜLLER'SCHES VOLKSBAD

Rosenheimer Straße 1 // Haidhausen
Tel.: +49 (0)89 23 61 50 50
www.swm.de/privatkunden/m-baeder/schwimmen/
hallenbaeder/volksbad.html

Mon–Sun 7.30 am to 11 pm, big pool Mon 7.30 to 5 pm
Sauna Mon–Sun 9 am to 11 pm
S1–8, Tram 17 Isartor, Tram 18 Deutsches Museum

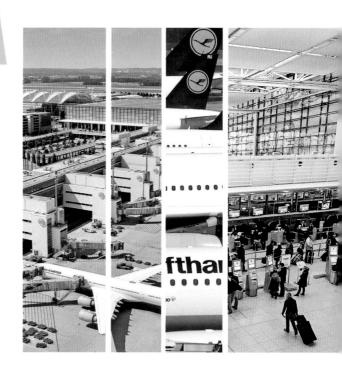

TERMINAL 2
FLUGHAFEN MÜNCHEN

Nordallee 25 // Hallbergmoos
Tel.: +49 (0)89 9 75 00
www.munich-airport.de

S1, S8, Airport Bus to and from city centre

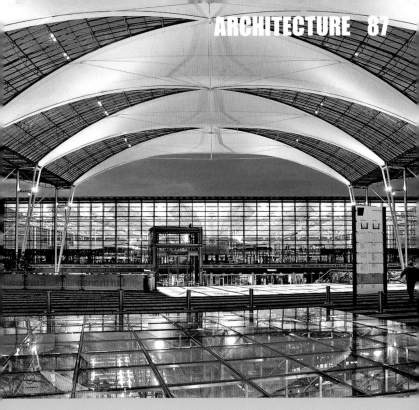

The next time you're at Munich Airport, make sure you stop by Terminal 2. Munich-based architects Koch + Partner met the airport operator's demanding functional, acoustic, aesthetic, and climatic requirements with a sophisticated steel construction. The 250,000 sq. ft. central hall won the 2005 European Steel Design Award. In total, the new terminal occupies 3.2 million sq. ft. Each year, about 25 million passengers pass through Terminal 2.

Wenn man nach München fliegt, lohnt es sich, noch kurz am Flughafen zu verweilen und den Terminal 2 zu besichtigen. Die Münchner Architekten Koch + Partner haben die hohen Anforderungen an Funktionalität, Akustik, Ästhetik und Klimatisierung in einer ausgeklügelten Stahlkonstruktion umgesetzt. Die 23 000 m² große zentrale Halle wurde mit dem „Europäischen Stahlbaupreis 2005" ausgezeichnet. Insgesamt misst der neue Terminal 300 000 m². Pro Jahr landen oder starten hier ca. 25 Millionen Fluggäste.

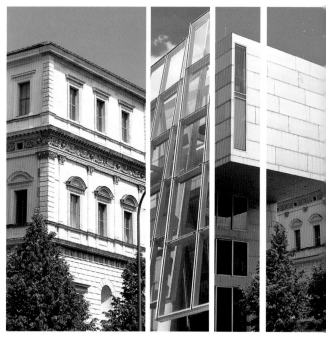

AKADEMIE DER BILDENDEN KÜNSTE

Akademiestraße 2-4 // Maxvorstadt
Tel.: +49 (0)89 3 85 20
www.adbk.de

Old building Mon–Fri 7 am to 9 pm
Sat 10 am to 5 pm
New building Mon–Fri 7 am to 8 pm
U3, U6 Universität

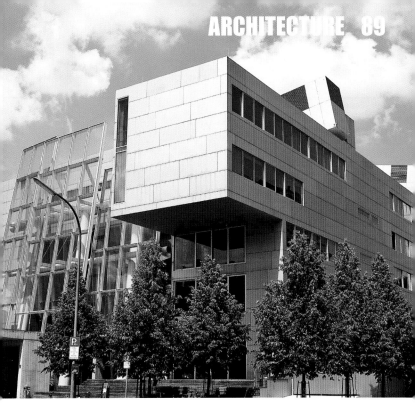

The elongated Renaissance complex opened in 1885 after 10 years of construction. Less than 100 years later, lack of space prompted the academy to think about expanding. Between 2003 and 2005, the "architecture punks" at COOP HIMMELB(L)AU realized their concept, which was highly polarizing. While the annex has proportions similar to Gottfried von Neureuther's original building, its design idiom is completely different: traditional austerity meets planned anarchy.

Nach zehn Jahren Bauzeit konnte die langgestreckte Renaissance-Anlage 1885 bezogen werden. Hundert Jahre später zwingt der Platzmangel über Erweiterungspläne nachzudenken. Schließlich verwirklichten zwischen 2003 und 2005 die „Architekturpunks" COOP HIMMELB(L)AU ihr – natürlich stark polarisierendes – Konzept. Proportional geht der Anbau auf das Gebäude von Gottfried von Neureuther ein, aber die Formensprache ist denkbar konträr: Alte Strenge trifft auf geplante Anarchie.

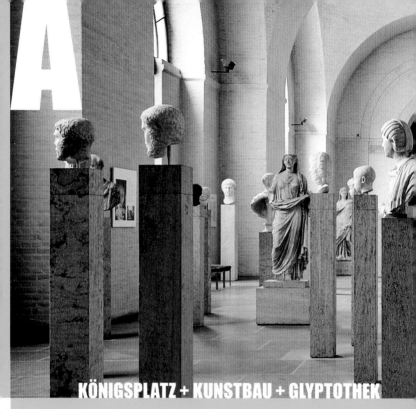

KÖNIGSPLATZ + KUNSTBAU + GLYPTOTHEK

Munich as Athens on the Isar? No place in Munich embodies King Ludwig I's vision better than the Königsplatz completed in 1862. Karl von Fischer's design was inspired by the Acropolis in Athens. Leo von Klenze created the Propylaea—the Greek Monument of Liberty—and the Glyptothek. The latter houses sculptures from four epochs of Greek and Roman antiquity; its interior is well worth a visit. Straight across is the Collection of Antiquities built by Georg Friedrich Ziebland in the Corinthian style. The entrance to the Kunstbau is behind the Propylaea, marked by white container structures—a soothing contrast to the monumental buildings on the Königsplatz. The unused "mezzanine" between the U-Bahn station and street level was converted into an exhibition space by architect Uwe Kiessler.

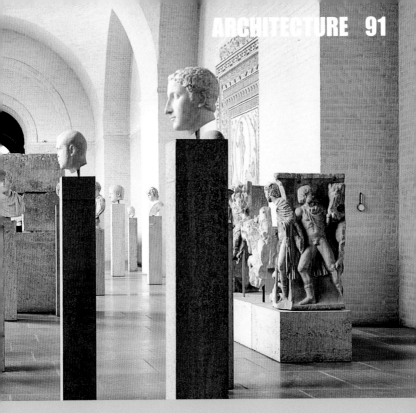

München als Isar-Athen? Kein Ort in München verkörpert die Vision von König Ludwig I.
stärker als der 1862 vollendete Königsplatz. Karl von Fischer konzipierte ihn nach
dem Vorbild der Akropolis. Leo von Klenze entwarf das griechische Freiheits-
denkmal, die sogenannten Propyläen, und die Glyptothek. Letztere beherbergt
Skulpturen aus vier Epochen der griechischen und römischen Antike und ist
unbedingt empfehlenswert. Direkt gegenüber liegt die von Georg Friedrich Ziebland
im korinthischen Stil erbaute Antikensammlung. Hinter den Propyläen befindet
sich der Eingang zum Kunstbau, weiße Containerbauten markieren den Eingang –
ein wohltuender Kontrast zu den klassizistischen Prachtbauten. Das ungenutzte
„Zwischengeschoss" zwischen U-Bahn und Erdoberfläche wurde vom Architekten
Uwe Kiessler zu einem Ausstellungsort umgebaut.

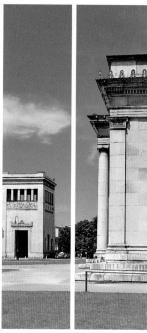

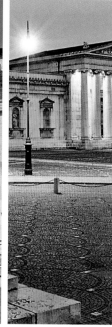

KÖNIGSPLATZ

Maxvorstadt

U2 Königsplatz

KUNSTBAU

Königsplatz // Maxvorstadt
Tel.: +49 (0)89 23 33 20 00
www.lenbachhaus.de

Tue–Sun and holidays 10 am to 6 pm
U2 Königsplatz

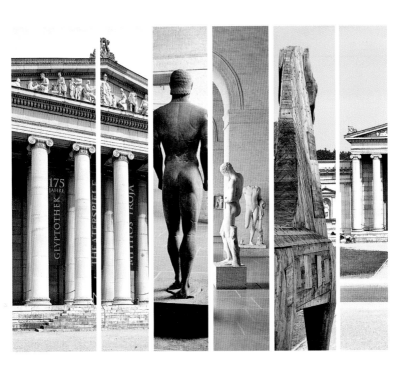

GLYPTOTHEK

Königsplatz // Maxvorstadt
Tel.: +49 (0)89 28 61 00
www.antike-am-koenigsplatz.mwn.de/glyptothek

Tue–Sun 10 am to 5 pm
Thu 10 am to 8 pm
U2 Königsplatz

PALAIS
MAI

In terms of creative teamwork, Palais Mai is Munich's architectural spearhead. Ina-Maria Schmidbauer, Patrick von Ridder, Peter Scheller, and their team involve the "end users" in the early planning and development process. The scouts in Ottobrunn are a perfect example of this—their house floats in the woods like a weightless tent. A true marvel. The office also designs reusable mobile exhibition modules such as the temporary buildings at the Kunstbau on Königsplatz used for the Franz Marc retrospective in 2005. Palais Mai deliberately provokes the public, for instance by setting up shipping containers—simulating a harbor and other visionary utopias—in the middle of the city and questioning Munich's urban future. Yet the architects are also true preservationists, visible in their modernization of the historic Riding School. In 2011, the City of Munich acknowledged Palais Mai with its Award for the Advancement of Architecture since the company, in the words of the jury, does not shy away from confrontation.

Bei der Zusammenarbeit von Kreativen in München sticht Palais Mai als architektonische Speerspitze heraus: Ina-Maria Schmidbauer, Patrick von Ridder, Peter Scheller und ihr Team binden die „Endabnehmer" bereits in den Planungs- und Entstehungsprozess mit ein. Wie die Pfadfinder in Ottobrunn, deren Haus nun im Wald schwebt wie ein schwereloses Zelt. Ein Wunderwerk. Das Büro ersinnt auch mobile, wieder verwertbare Ausstellungsmodule wie die „Fliegenden Bauten" am Kunstbau auf dem Königsplatz für die Franz-Marc-Retrospektive 2005. Und es eckt immer wieder bewusst – und sichtbar – an, wie durch das Aufstellen von Schiffscontainern, der Simulation eines Hafens und anderer visionärer Utopien mitten in der Stadt, und stellt Fragen an die urbane Zukunft in den Raum. Aber die Architekten sind auch behutsame Bewahrer, wie die Modernisierung der traditionsreichen Reitschule zeigt. Mit dem Förderpreis für Architektur würdigt die Landeshauptstadt München 2011 die ideenreiche Beharrlichkeit von Palais Mai, das, laut Jury, keine Konfrontation scheut.

A

Completed in 1993, this Herzog & de Meuron-designed building allows Ingvild Goetz to make her extensive collection of contemporary art available to the public. The simple cubical body consists of two sections of frosted glass and birchwood, layered on top of each other in mirror fashion. The main exhibition space is in the basement; three additional smaller exhibitions rooms are located on the upper level. Evenly diffused daylight creates the ideal environment to enjoy the artwork.

In dem 1993 von Herzog & de Meuron fertiggestellten Gebäude macht Ingvild Goetz in Wechselausstellungen ihre bedeutende Sammlung zeitgenössischer Kunst der Öffentlichkeit zugänglich. Der schlichte, kubische Körper besteht aus zwei spiegelbildlich aufeinandergeschichteten Elementen aus mattem Glas und Birken-holz. Der große Ausstellungssaal befindet sich im Keller, im oberen Stockwerk gibt es drei weitere kleinere Ausstellungsräu-me – gleichmäßig einfallendes Tageslicht sorgt überall für ungetrübten Kunstgenuss.

SAMMLUNG GOETZ

Oberföhringer Straße 103 // Oberföhring
Tel.: +49 (0)89 95 93 96 90
www.sammlung-goetz.de

Only on appointment, Mon–Fri 2 pm to 6 pm, Sat 11 am to 4 pm
U4 Arabellapark, then Bus 59 Salzsenderweg
Tram 17, 18, Bus 54 Herkomerplatz,
then Bus 188 Bürgerpark Oberföhring

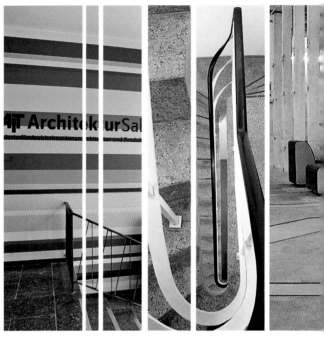

AIT-ARCHITEKTURSALON

Arcisstraße 68-74 // Schwabing
Tel.: +49 (0)89 2 19 69 10 51
www.muenchen.ait-architektursalon.de

Tue–Wed 11 am to 5 pm, Thu–Fri 11 am to 8 pm
Sat 1 pm to 5 pm
U2 Josephsplatz, Tram 27 Elisabethplatz

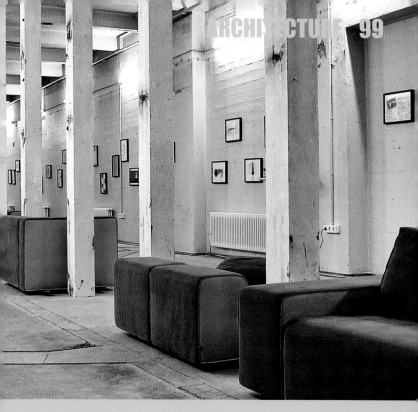

AIT-ArchitekturSalon describes itself as a "high-quality gallery for architecture and design issues." Together with its existing partner galleries in Hamburg, Cologne, and soon also Stuttgart and Rotterdam, it is operated by architecture magazine AIT. The Munich venue is housed in what used to be a transformer station; the transformer room in the basement is a fantastic—and frequently used—backdrop for exhibitions. The salon on Elisabeth-platz also offers classes, lectures, and an architecture film program.

Der AIT-ArchitekturSalon beschreibt sich selbst als „hochwertige Galerie für Architektur- und Gestaltungsfragen" und wird, zusammen mit den Partnergalerien in Hamburg, Köln und demnächst auch Stuttgart und Rotterdam von der Architekturzeitschrift AIT betrieben. Heimstatt in München ist ein altes Umspannwerk – der alte Traforaum im Keller ist eine traumhafte Ausstellungskulisse, die vielfältig genutzt wird. Zum Programm des Salons am Elisabethplatz gehören auch Kurse, Vorträge und eine Architektur-Filmreihe.

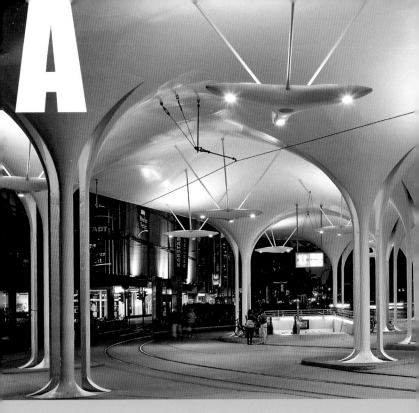

A

Within a very short time, the Münchner Freiheit U-Bahn station has gone from being a somewhat dingy public transportation hub to a showroom of modern architecture. While the U-Bahn area is looking spiffy thanks to Ingo Maurer's lighting concept, the above-ground stop, opened in 2009, rises into the sky like a modern-day cathedral. Designed by OX2architekten, the flowing steel construction consists of 18 open columns and a 440-ton domed roof.

Binnen kürzester Zeit hat sich die Münchner Freiheit vom etwas schmuddeligen Knotenpunkt des öffentlichen Nahverkehrs zum Showroom für moderne Architektur gewandelt. Während der U-Bahn-Bereich dank Ingo Maurer in neuem Licht erstrahlt, erhebt sich überirdisch die 2009 in Betrieb genommene Haltestelle wie eine moderne Kathedrale. Die von OX2architekten entworfene fließende Stahlkonstruktion besteht aus 18 offenen Säulen und einem 400 Tonnen schweren aufgeschlitzten Gewölbedach.

TRAMHALTESTELLE MÜNCHNER FREIHEIT

Münchner Freiheit // Schwabing

U3, U6, Tram 23 Münchner Freiheit

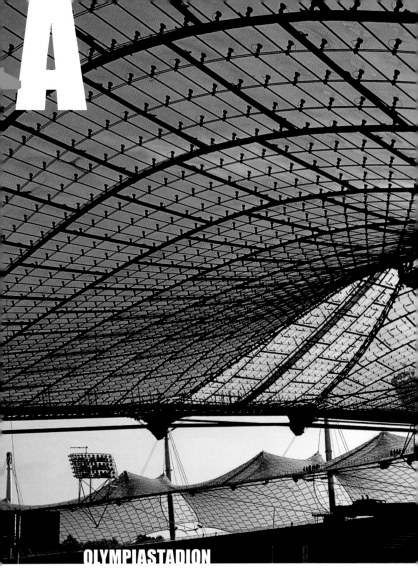

A

OLYMPIASTADION

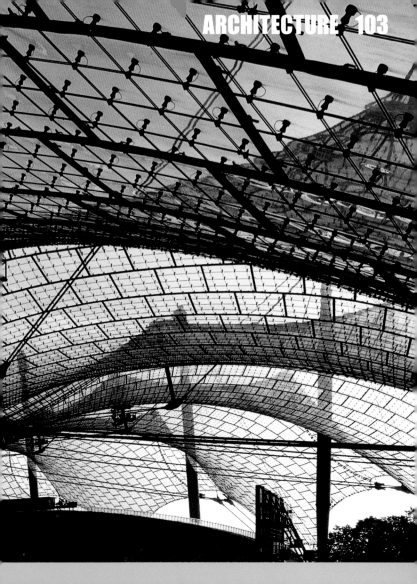

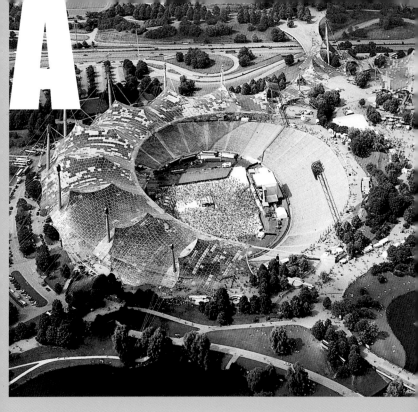

A

For the 1972 Olympic Summer Games, architect Günter Behnisch and his colleagues turned the 740 acre Oberwiesenfeld site into the Olympiapark. The sweeping canopy roof by Frei Otto is a fitting interpretation of the original theme of "green Olympic Games," and the organic shell provides a light and airy cover. Since FC Bayern's move to Allianz Arena, the Olympic Stadium may not be in the limelight as much as it used to be, but it's still Munich's best-known landmark.

Für die 1972 ausgetragenen Olympischen Sommerspiele wurde das 3 000 m² große Oberwiesenfeld von einer Architektengruppe um Günter Behnisch zum Olympiapark umgestaltet. Die markante Zeltdachkonstruktion von Frei Otto passt zum damaligen Arbeitstitel „Olympische Spiele im Grünen" – luftig leicht überzieht die organische Hülle die Anlage. Auch wenn es seit dem Umzug des FC Bayern in die Allianz Arena nicht mehr ständig im Rampenlicht steht, das Olympiastadion ist das Wahrzeichen Münchens.

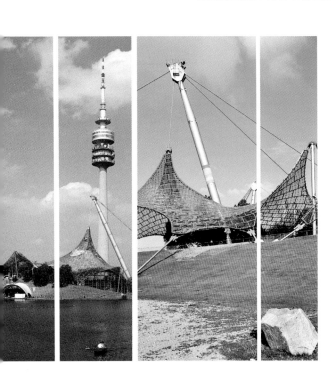

OLYMPIASTADION

Spiridon-Louis-Ring 21 // Schwabing-West
Tel.: +49 (0)89 3 06 70
www.olympiapark.de

Check website for opening times, guided tours,
and special events
U3 Olympiazentrum, Tram 20, 21 Olympiapark West
Bus 173 Olympiapark-Eisstadion

Opened in 2005, the Central Bus Station (ZOB) combines transportation, restaurants, retail, and entertainment. The exterior brings to mind the power head of a high-speed ICE train. The aluminum tubes that make up the building envelope are reminiscent of train tracks and allude to the nearby Hauptbahnhof. Say what you will about the interior design, Konstantin Grcic's "Chair One" chairs in the waiting area are very stylish.

Der 2005 eröffnete Zentrale Omnibusbahnhof (ZOB) vereint Verkehr, Gastronomie, Einzelhandel und Unterhaltung. Äußerlich erinnert er an einen ICE-Triebwerkkopf, was einen dynamischen Eindruck macht. Die Verkleidung mit Aluminiumrohren reflektiert die Lage an den Schienen und die Nachbarschaft zum Hauptbahnhof. Über die Gestaltung kann man sagen, was man will – im Wartebereich sitzt es sich auf Konstantin Grcics „Chair One" sehr stilvoll.

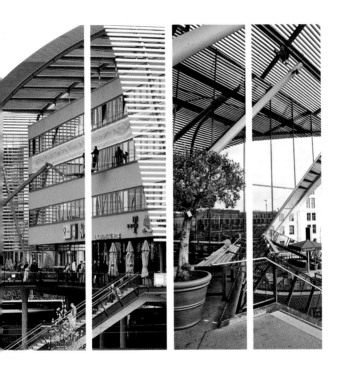

ZENTRALER OMNIBUSBAHNHOF

Hackerbrücke 4 // Schwanthalerhöhe
Tel.: +49 (0)89 45 20 98 90
www.muenchen-zob.de

Check website for bus schedules, shops,
and restaurants
S1–8 Hackerbrücke

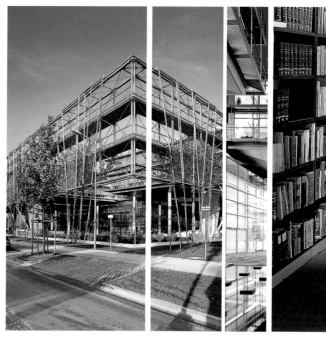

SWISS RE

Dieselstraße 11 // Unterföhring
Tel.: +49 (0)89 3 84 40
www.swissre.com

Open during office hours
S8 Unterföhring

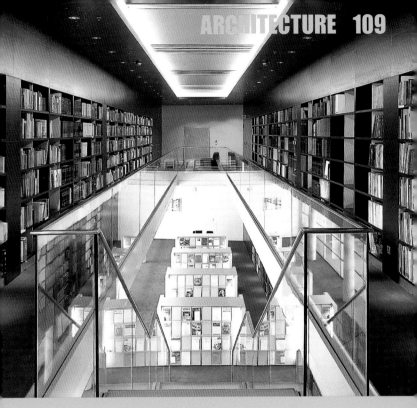

The Hamburg-based firm BRT Architekten faced quite a challenge: how to integrate an office complex into an urban planning context that doesn't exist. Architecturally speaking, it wouldn't be farfetched to call the Swiss Re building in Unterföhring's industrial district a "cathedral in the wilderness." Nature appears to dominate the structure surrounded by a floating hedge. From each workspace, employees have views of gardens, green roofs, or interior courtyards.

Das Hamburger Büro der BRT Architekten stand vor der Herausforderung, die Büroanlage in einen städtebaulichen Kontext einzubeziehen, der keiner ist: Man könnte das Gebäude von Swiss Re im Gewerbegebiet von Unterföhring – aus architektonischer Sicht – durchaus als Kathedrale in der Wüste bezeichnen. Tatsächlich scheint die Natur den von einer „schwebenden Hecke" umgebenen Bau zu dominieren. Von jedem Arbeitsplatz blickt man auf Gärten, begrünte Dächer oder Innenhöfe.

DESIGN

It is amazing how outstanding design "Made in Munich" is. Perhaps it is because—unlike its big brother in Berlin—the local creative scene is under considerably less pressure to fit a specific image, enabling it to create spectacular works in peace. It could also be that the city is more manageable and the players are more closely networked. Lighting magician Ingo Maurer is one of the standouts, and his genius is revealed in his Schwabing headquarters, visible even from the subway. Mirko Borsche's internationally renowned graphic designs and artworks are impossible to miss—his signature is seen all over the city. And anyone who goes out in Munich (to the Goldene Bar museum café or the restaurant on Roecklplatz, for example) has at one point or another sat on an object made by industry design legend Konstantin Grcic. The quick-witted creative office of Designliga designs stages for flamboyant characters and graces the city with large-scale works of art, such as Armin Stegbauer's Café Kubitscheck and Christina Nemetz' Salon Nemetz.

Man kann nur darüber staunen, wie hochkarätig das Design „Made in Munich" ist. Vielleicht liegt es daran, dass die Münchner Kreativszene, im Gegensatz zum großen „Bruder" Berlin, weniger unter Druck steht, einem Image zu entsprechen und so in Ruhe Spektakuläres schaffen kann. Ein weiterer Grund mag die Überschaubarkeit der Stadt und die starke Vernetzung zwischen den Akteuren sein. Der Lichtmagier Ingo Maurer ist einer der Größten, dessen Genie sich in seiner Schwabinger Zentrale, aber auch von der U-Bahn aus betrachtet, offenbart. An Mirko Borsches international gefeiertem Grafikdesign und Artwork kommt niemand vorbei, seine Handschrift prägt die Stadt. Und jeder, der in München ausgeht (in die Goldene Bar oder ins Restaurant Roecklplatz), hat schon mal auf einem Objekt der Industriedesignlegende Konstantin Grcic gesessen. Das schlagfertige Kreativbüro Designliga entwickelt Bühnen für schillernde Persönlichkeiten – und schenkt der Stadt Gesamtkunstwerke wie Armin Stegbauers Café Kubitscheck und Christina Nemetz' Salon Nemetz.

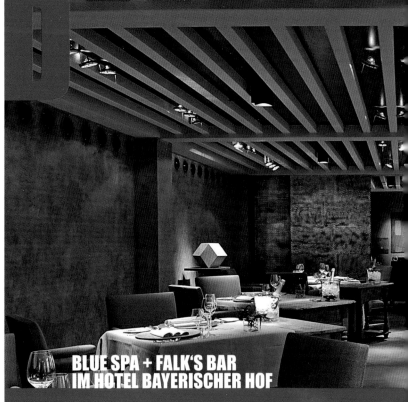

BLUE SPA + FALK'S BAR
IM HOTEL BAYERISCHER HOF

Commissioned by King Ludwig I, the Bayerischer Hof opened in 1841 to provide suitable accommodation for guests of state. Even if you're not a guest, the hotel is well worth a visit, not least because of the excellent falk's bar in the ballroom. Another highlight is the Restaurant Atelier, redesigned by Axel Vervoordt, whose use of elegant natural tones has turned the interior into a fitting backdrop for the star-awarded cuisine. The hotel's crown jewel, however, is the three-story Blue Spa with bar and roof terrace. The luxurious Cinema Lounge has just recently been opened.

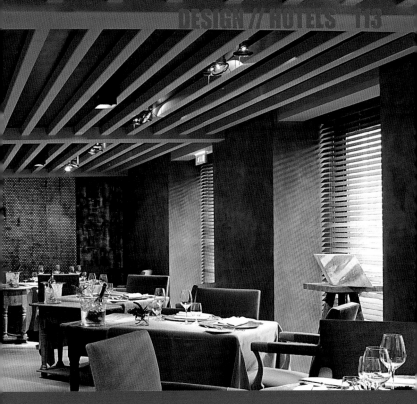

Der Bayerische Hof wurde 1841 auf Wunsch von König Ludwig I. eröffnet und diente der standesgemäßen Unterbringung wichtiger Staatsgäste. Auch Nicht-Hotelgästen sei ein Besuch empfohlen, z. B. in der großartigen falk's Bar im Spiegelsaal. Oder im von Axel Vervoordt eingerichteten Restaurant Atelier, dessen Interieur in eleganten Naturtönen die Sterneküche würdig umrahmt. Die Krönung ist das dreistöckige Blue Spa mit Bar und Dachterrasse. Das kleine Luxuskino Cinema Lounge wurde kürzlich eröffnet.

D

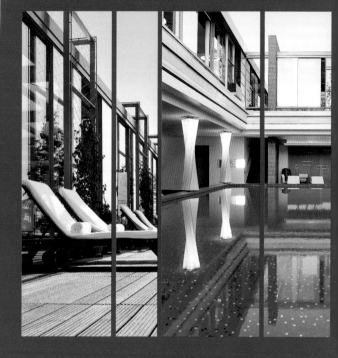

BLUE SPA

Promenadeplatz 2-6 // Altstadt
Tel.: +49 (0)89 2 12 08 75
www.bayerischerhof.de

Daily 8 am to 10.30 pm
S1–8, U3, U6 Marienplatz
Tram 19 Theatinerstraße

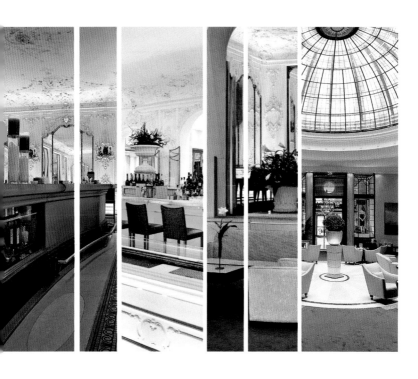

FALK'S BAR

Promenadeplatz 2-6 // Altstadt
Tel.: +49 (0)89 2 12 09 56
www.bayerischerhof.de

Daily 11 am to 2 pm
S1–8, U3, U6 Marienplatz
Tram 19 Theatinerstraße

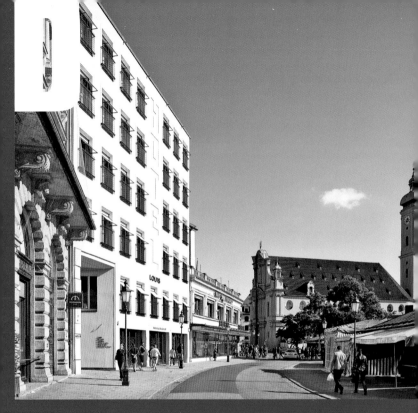

This marvelously chic hotel is located right on Viktualienmarkt. Designed by Hild und K Architekten, its facade is impossible to miss thanks to its sleek beauty. The Munich-based architecture firm also left its mark on the interior with furniture custom-designed for the hotel. The 72 rooms feature exquisite natural materials and carefully selected details such as "suitcase" wardrobes. The terrace is another reason to make a reservation without delay.

Direkt am Viktualienmarkt liegt dieses herrlich schicke Hotel. Seine von Hild und K gestaltete Fassade ist in ihrer schlichten Schönheit nicht zu übersehen. Mit eigens für das Hotel entworfenem Mobiliar hat das Münchner Architekturbüro das Design auch im Inneren maßgebend geprägt. Die 72 Zimmer sind mit feinsten Naturmaterialien ausgestattet und mit liebevollen Details wie „Reisekoffer"-Schränken versehen. Die Sonnenterrasse ist ein weiterer Grund sofort zu buchen.

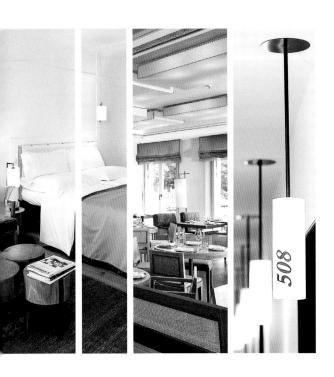

LOUIS HOTEL

Viktualienmarkt 6 (access via Rindermarkt 2) // Altstadt
Tel.: +49 (0)89 41 11 90 80
www.louis-hotel.com

S1–8, U3, U6 Marienplatz

ANNA HOTEL

Schützenstraße 1 // Ludwigsvorstadt
Tel.: +49 (0)89 59 99 40
www.annahotel.de

S1–8 Hauptbahnhof or Karlsplatz (Stachus)
U1, U2, U4, U5 Hauptbahnhof

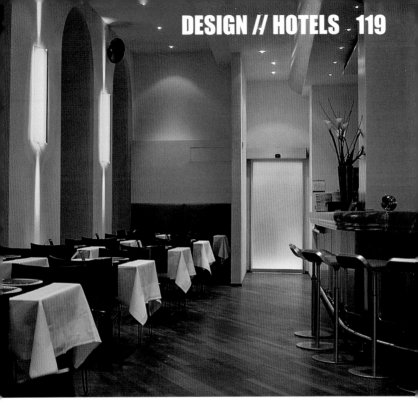

Traditional meets modern—this describes the Geisel family and their most recent project to a T. Their design hotel is just a stone's throw from the Hauptbahnhof; it was named "Anna" in honor of their great-grandmother. The sleek and elegant (interior) architecture is by Jochen Dahms, the furnishings are by New York interior design label Donghia. The hotel also features a dynamic lighting concept that can simulate any time of day or mood.

Tradition und Moderne – das beschreibt die Familie Geisel und ihr jüngstes Projekt recht treffend. Einen Steinwurf vom Hauptbahnhof entfernt liegt ihr Designhotel, das zu Ehren der Urgroßmutter auf den Namen Anna getauft wurde. Die klare, edle (Innen-)Architektur stammt von Jochen Dahms, die Einrichtungsstücke sind vom New Yorker Interieurdesign-Label Donghia. Eine Besonderheit des Hotels ist das dynamische Beleuchtungskonzept, das alle Tageszeiten oder Stimmungen zaubern kann.

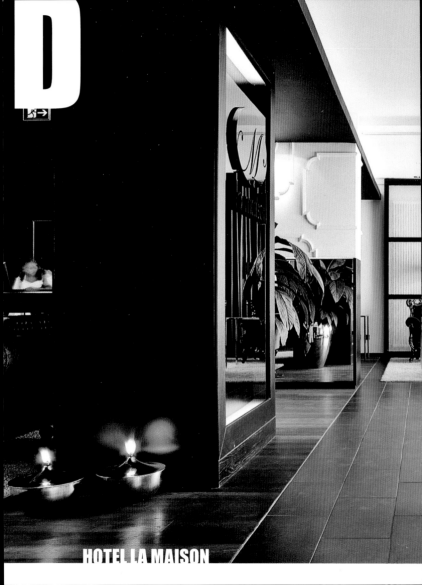

D

HOTEL LA MAISON

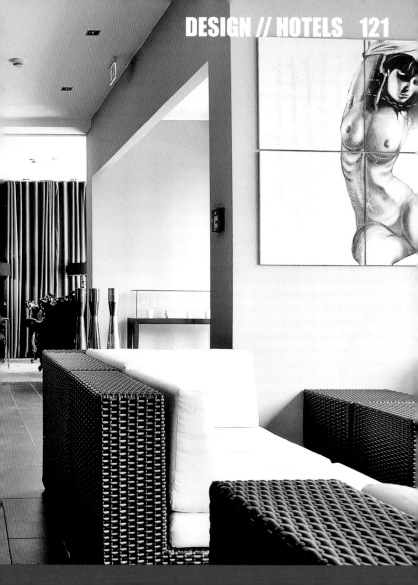

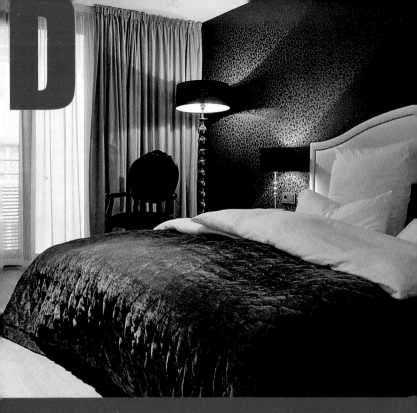

With only 31 rooms, of which 19 have a balcony or terrace, La Maison, managed by Philipp Kretschmer, is a small and very personal hotel. Located in a quiet spot between Leopoldstraße and the Englischer Garten, this boutique hotel is the perfect home base for a relaxing yet exciting stay. Lovers of unabashedly ornate design will be in heaven. The entire interior design was created by Koubek & Hartinger.

Mit nur 31 Zimmern, davon 19 mit Balkon oder Terrasse, ist das von Philipp Kretschmer geführte La Maison ein kleines, persönliches Haus. Seine ruhige Lage zwischen Leopoldstraße und dem Englischen Garten macht das Boutique-Hotel zum perfekten Ausgangspunkt für einen entspannten und abwechslungsreichen Aufenthalt. Liebhaber von entschieden verschnörkeltem Design kommen hier voll auf ihre Kosten. Die gesamte Innenarchitektur stammt von Koubek & Hartinger.

HOTEL LA MAISON

Occamstraße 24 // Schwabing
Tel.: +49 (0)89 33 03 55 50
www.hotel-la-maison.com

U3, U6, Tram 23 Münchner Freiheit

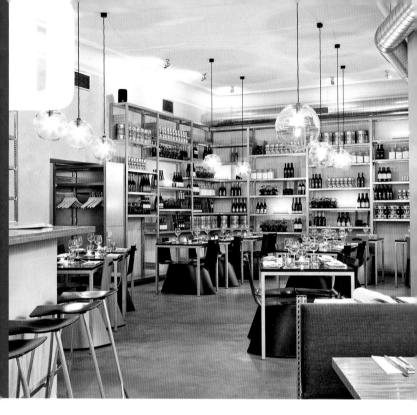

It doesn't get better than this: a socially sustainable concept, a top-notch kitchen, and first-rate design. The "Training Restaurant for Disadvantaged Youths" created by Munich restaurateurs Sandra Forster, Markus Frankl, and Michi Kern is a stroke of genius. Their trainees run the friendly and comfortable Roecklplatz with both heart and common sense. The interior design is by Nitzan Cohen, who received the City of Munich's 2011 Design Award, and features pieces by Konstantin Grcic.

Besser geht's nicht: ein sozial nachhaltiges Konzept, erstklassige Küche und ein 1-a-Design. Den Münchner Profigastronomen Sandra Forster, Markus Frankl und Michi Kern ist mit ihrem „Ausbildungsgasthaus für benachteiligte Jugendliche" ein Geniestreich gelungen. Und ihre Azubis führen das freundliche, gemütliche Roecklplatz mit Herzblut, Sinn und Verstand. Gestaltet hat es Nitzan Cohen, 2011 ausgezeichnet mit dem Förderpreis der Stadt für Design, u. a. mit Stücken von Konstantin Grcic.

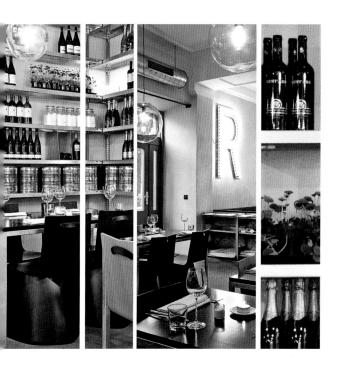

ROECKLPLATZ

Isartalstraße 26 // Isarvorstadt
Tel.: +49 (0)89 45 21 71 29
www.roecklplatz.de

Mon–Sat 5 pm to 1 am
U3, U6 Implerstraße
Bus 58 Kapuzinerstraße

A paradise for meat eaters and railfans alike: bratar serves the best bratwurst and burgers—all organic and prepared with the utmost care—and offers great views of the train tracks between the Hauptbahnhof and Hackerbrücke. Owners Dirk Plechinger and Thomas Reese didn't take any shortcuts when it came to the design of this down-to-earth restaurant in the Central Bus Station (ZOB). Everything from the sauces and the graphics to the interior creek was created by the two of them.

Ein Traum für bewusste Fleischesser und „Trainspotter": Im bratar gibt es die besten Bratwürste und Burger – alles bio und mit größter Sorgfalt zubereitet – und dazu dann diese Sicht auf die Schienen zwischen Hauptbahnhof und Hackerbrücke. Nicht nur in puncto Qualität, auch in der Gestaltung des ehrlichen Ladens im ZOB haben sich Dirk Plechinger und Thomas Reese nichts geschenkt. Von den Saucen über die Grafik bis hin zum hauseigenen Bach ist alles selbst erdacht und gemacht.

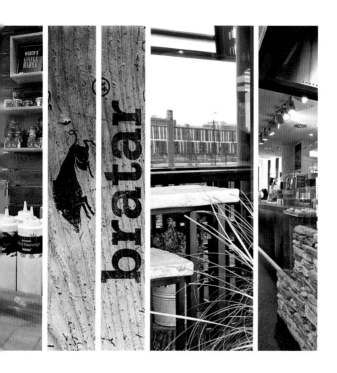

BRATAR

Hackerbrücke 4 // Schwanthalerhöhe
Tel.: +49 (0)89 55 07 77 77
www.bratar.de

Mon–Sat 10 am to 10 pm
S1–8 Hackerbrücke

DELI @ DESIGNREISEN / DESIGNRAUM

Brienner Straße 7 // Maxvorstadt
Tel.: +49 (0)89 25 54 92 88
www.deli-muenchen.com

Mon–Sat 8.30 am to 7 pm
U3, U4, U5, U6 Odeonsplatz

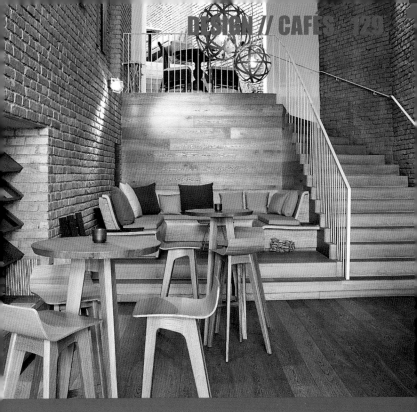

Unusual for classy Brienner Straße, the inconspicuous entrance conceals a wonderful space with 20 foot high ceilings and exposed brick walls. Three concepts merge on two levels in stimulating harmony to create a congenial high-end cooperative venture: deli, headed by Elias Nogård, serves both as a showroom for the designraum team as well as a cozy conference room. And designreisen on the upper level, with its luxurious vacation destinations, inspires the exquisite deli cuisine.

Hinter dem – für die noble Brienner Straße – unscheinbaren Eingang verbirgt sich ein wunderbarer Raum mit sechs Metern Deckenhöhe und rohen, mattierten Ziegelwänden. Drei sich gegenseitig befruchtende Konzepte auf zwei Ebenen bilden hier eine sympathische „High-End-Wohngemeinschaft": Das von Elias Nogård geführte deli dient dem designraum-Team als Showroom und als gemütlicher Besprechungsraum. Und designreisen auf der oberen Etage inspiriert mit seinen luxuriösen Urlaubsziele die feine deli-Küche.

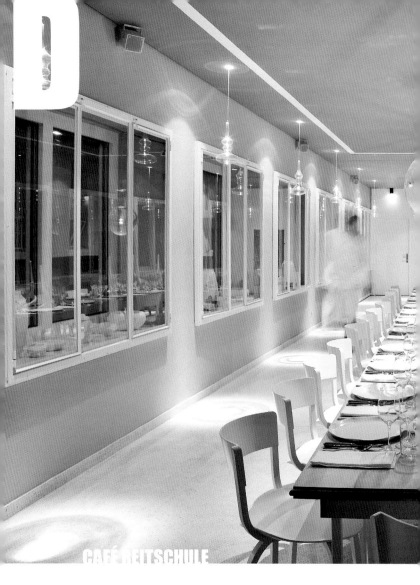

D

CAFÉ REITSCHULE

CAFÉ REITSCHULE

Königinstraße 34 // Schwabing
Tel.: +49 (0)89 3 88 87 60
www.cafe-reitschule.de

Mon–Sat 9 am to 1 am
Sun 9 am to 7 pm
U3, U6 Giselastraße

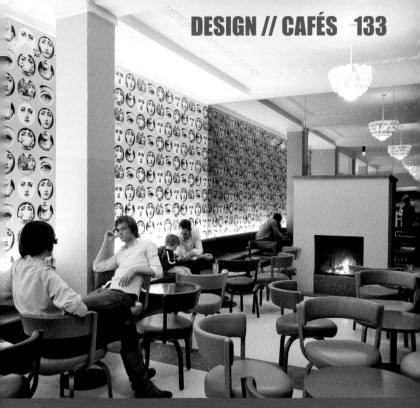

The rebirth of a Schwabing institution: after extensive renovations to the historical building next to the Englischer Garten, Palais Mai, with assistance from Stefan Diez and others, started to work on the interior. Classical elements were re-interpreted in the building's café, salon, restaurant, orangerie, and bar. Porcelain chandeliers and a drinking fountain are juxtaposed against wallpaper by illustrator Piero Fornasetti. The indoor arena, visible from the café, is spectacular.

Die Wiedergeburt einer Schwabinger Institution: Nach aufwendiger Generalsanierung des denkmalgeschützten Gebäudes am Englischen Garten hat sich Palais Mai, u. a. unterstützt von Stefan Diez, an den Innenausbau gemacht. In den fünf Bereichen Café, Salon, Restaurant, Orangerie und Bar wurden Klassiker neu interpretiert. Lüster aus Porzellan und ein Trinkbrunnen treffen auf eine Tapete des Illustrators Piero Fornasetti. Unschlagbar ist und bleibt die einsehbare Reithalle.

D

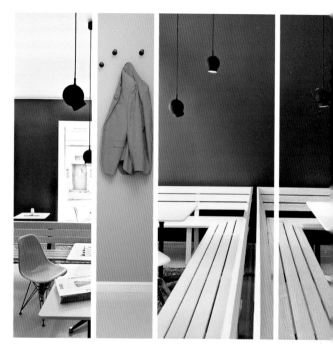

DAS NEUE KUBITSCHECK

Gollierstraße 14 // Schwanthalerhöhe
Tel.: +49 (0)89 72 66 92 22
www.das-neue-kubitscheck.de

Mon–Fri 9 am to 10 pm, Sat–Sun and holidays 10 am to 10 pm
S1–8 Hackerbrücke
U4, U5 Schwanthalerhöhe

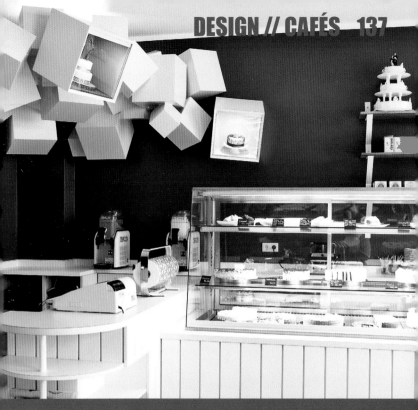

Armin Stegbauer, Designliga, plus an electro version of "Once Upon a Time in the West"—those were the initial ingredients. An explosive combination that took off: design blogs around the world celebrate the shrill yet sleek interior and bring customers to Kubitscheck who otherwise might not find their way to Munich's West End. The gilded Joseph Beuys Torte triggered torte happenings and creative cooperations, for instance with Patrick Mohr and his "Consonance of the Elements."

Armin Stegbauer, die Designliga und eine Elektroversion von „Spiel mir das Lied vom Tod" – das waren die anfänglichen Zutaten. Eine explosive Mischung, die voll aufgegangen ist: Designblogs weltweit feiern das schrille und doch schlichte Interieur und bescheren dem Kubitscheck zuweilen Kundschaft, die sonst kaum ins Westend fände. Die vergoldete Joseph-Beuys-Torte löste Torten-Happenings und kreative Kooperationen aus, so mit Patrick Mohr und seinem „Gleichklang der Elemente".

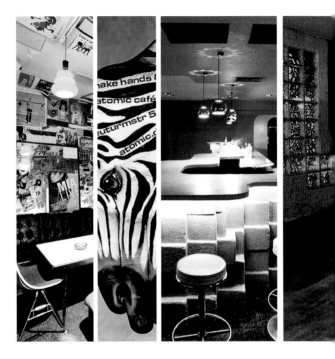

THE ATOMIC CAFÉ

Neuturmstraße 5 // Altstadt
Tel.: +49 (0)89 30 77 72 32
www.atomic.de

Check website for current events, concerts, and clubnights
S1–8, U3, U6 Marienplatz

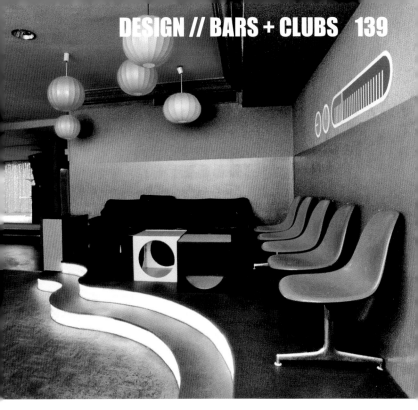

This Munich institution takes its name from a documentary about the public perception of the atomic bomb in the USA in the 1940s and 50s. Aptly, the furnishings were inspired by the California Googie style that was popular into the 1960s: retro futuristic designs, warm colors, and rounded shapes. The music—including soul, jazz, funk, indie, ska, and electro—is eclectic and danceable, and the concert program of this small club is fantastic.

Diese Münchner Institution ist nach dem gleichnamigen Dokumentarfilm über die öffentliche Wahrnehmung der Atombombe in den USA der 1940er und 50er Jahre benannt. Konsequenterweise ist die Einrichtung vom bis in die 1960er Jahre populären kalifornischen Googie-Stil inspiriert, d. h. Retro-Futurismus, warme Farben, runde Formen. Das musikalische Angebot (u. a. Soul, Jazz, Funk, Indie, Ska, Elektro) ist eklektisch und tanzbar und das Konzertprogramm des kleinen Clubs großartig.

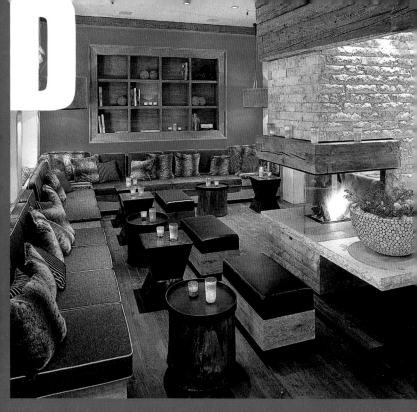

It all started in 1930 when Paul and Elsa Käfer opened a grocery store on Amalien-straße. Today, Käfer is a Munich institution with an international presence. The flagship store on Prinzregentenstraße is a paradise for epicures and gourmets. Featuring an open fireplace, a small library, and lots of fur and leather, the lounge is an oasis of relaxation—the ideal hangout to while away time between shopping in the delicatessen and eating in the restaurant.

Mit dem Kolonialwarengeschäft von Paul und Elsa Käfer in der Amalienstraße fing 1930 alles an. Heute ist Käfer eine welt-weit agierende Münchner Institution. Das Stammhaus in der Prinzregentenstraße ist ein Traum für alle Feinschmecker und Genießer. In der Lounge, die mit offenem Kamin, kleiner Bibliothek und viel Fell und Leder ganz auf Entspannung ausgerichtet ist, lässt sich die Zeit zwischen dem Einkauf im Delikatessenladen und dem Essen im Restaurant optimal überbrücken.

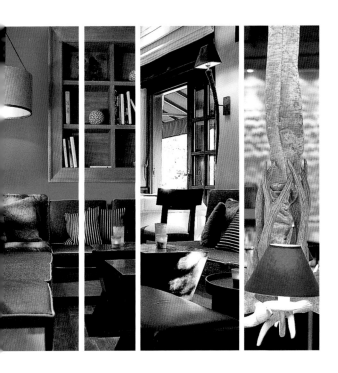

KÄFER LOUNGE

Prinzregentenstraße 73 // Bogenhausen
Tel.: +49 (0)89 4 16 82 47
www.feinkost-kaefer.de

Mon–Sat 11.30 am to 1 am
Tram 18 Friedensengel
U4 Prinzregentenplatz

LODENFREY

Maffeistraße 7 // Altstadt
Tel.: +49 (0)89 21 03 90
www.lodenfrey.com

Mon–Sat 10 am to 8 pm
S1–8, U3, U6 Marienplatz
Tram 19 Theatinerstraße

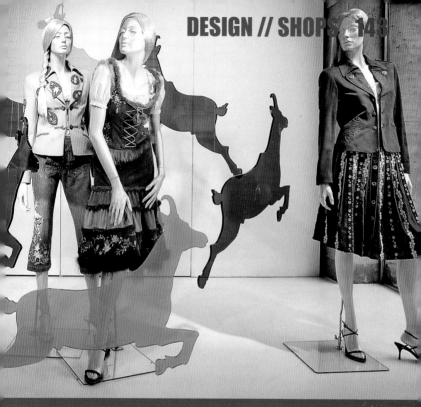

The son of a Swabian clothier, whose mother sent him to Munich with a few guilders in his pocket, quickly became a rising star in the cloth trade. The clothing store Johann Georg Frey, originally founded in 1842 as a weaving mill, is still owned by the sixth generation of his family. The Freys' fame is based on the invention of a water-resistant loden fabric. Redesigned by Kiessler + Partner, the store near the Frauenkirche sells traditional loden clothing as well as fashion from leading labels.

Aus dem Sohn einer schwäbischen Tuchmacherfamilie, den seine Mutter mit ein paar Gulden nach München schickte, wurde schnell ein „Shootingstar" der Textilbranche. Das 1842 von ihm als Weberei gegründete Bekleidungshaus befindet sich mittlerweile in 6. Generation in Familienbesitz. Berühmt gemacht hat die Freys die Erfindung eines wasserabweisenden Lodenstoffs. Im von Kiessler + Partner umgestalteten Verkaufshaus am Dom findet man heute neben Trachten- auch andere erlesene Labels.

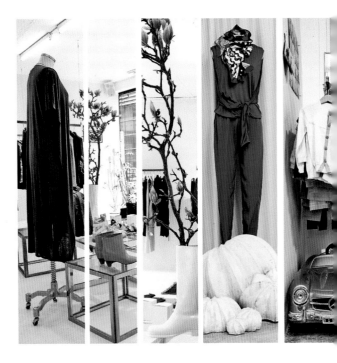

SCHWITTENBERG

Hildegardstraße 2 // Altstadt
Tel.: +49 (0)89 26 01 90 55
www.schwittenberg.com

Mon–Fri 11 am to 7 pm
Sat 11 am to 5 pm
S1–8, U3, U6 Marienplatz
Tram 19 Kammerspiele

"Schwittenberg" is Sandra Schwittau and Christopher Romberg's unique "Munich Retail Therapy." It isn't cheap and it's highly addictive, but no treatment could be more satisfying than what you'll find in this 2,150 sq. ft. haven of bliss. The gamut runs from Ayzit Bostan to Wood Wood, interspersed with exclusive objects like light ropes by Munich industrial designer Christian Haas. Some treasures are not for sale, such as the old photo of Sammy Davis Jr. on Maximilianstraße.

Unter dem Pseudonym Schwittenberg bieten Sandra Schwittau und Christopher Romberg die einzigartige „Münchner Shopping-Therapie" an. Sie ist nicht günstig und extrem suchtgefährlich, aber schöner als die 200-m²-Glücksgefühle von Ayzit Bostan bis Wood Wood kann Heilung nicht sein. Dazwischen finden sich exklusive Designobjekte wie die Lichtseile des Münchner Industriedesigners Christian Haas – und mit der alten Fotografie von Sammy Davis Jr. auf der Maximilianstraße auch unverkäufliche Schätze.

AYZIT
BOSTAN

Instead of sending models down the runway, Ayzit Bostan presented her 2010/11 collection in a video installation in the MaximiliansForum. For her "Not in Fashion" exhibition at the Museum für Moderne Kunst in Frankfurt am Main, dancers interpreted the minimalistic pieces in a live performance. Make no mistake, what Ayzit Bostan creates are pieces of art, yet they always allow wearers to express themselves. Her creations can be part of an art installation and flattering everyday clothes at the same time. Assuming they exist at all, this Munich native eliminates the boundaries between artistic disciplines. She designs costumes for movies and the stage, exhibits her creations in galleries, works for and with museums and architects—and designs outrageously gorgeous bags for Bree, a company with a long tradition. Aside from their elegant minimalism, her ideas often exhibit an inherently subtle humor, which this Zen master of fashion design often uses to diffuse cultural tensions.

Anstatt Models über den Laufsteg zu schicken, präsentiert sie ihre Kollektion 2010/11 in einer Videoinstallation mit Happening im MaximiliansForum. Im Rahmen der Ausstellung „Not in Fashion" im Museum für Moderne Kunst in Frankfurt am Main interpretieren Tänzerinnen in einer Live-Performance die auf das Wesentliche reduzierten Stücke. Und es sind Kunststücke, die Ayzit Bostan vollbringt, aber immer mit Raum für die Haltung des Tragenden. Ihre Kreationen können Teil einer Installation und gleichzeitig schmeichelhafte Alltagskleidung sein. Falls sie überhaupt existieren, hebt die Münchnerin die Grenzen zwischen den künstlerischen Disziplinen auf. Das Ganze im Sinn entwirft sie Kostüme für Film und Bühne, stellt in Galerien aus, arbeitet für und mit Museen und Architekten – von dem intergalaktisch schönen Taschendesign für das Traditionsunternehmen Bree ganz zu schweigen. Neben dem eleganten Minimalismus wohnt ihren Ideen nicht selten ein feiner Humor inne, mit dem die Zen-Meisterin des Modedesigns nebenbei kulturell entkrampft.

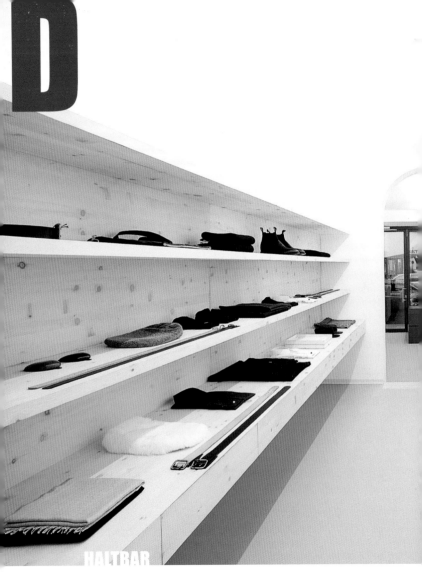

HALTBAR

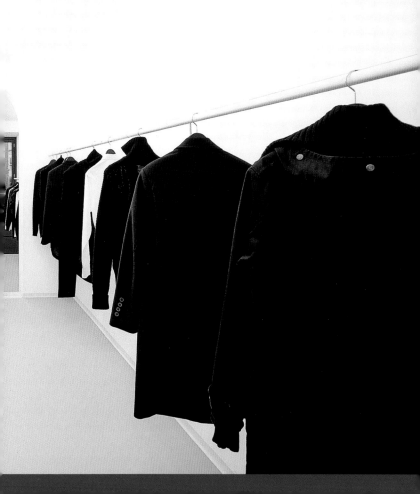

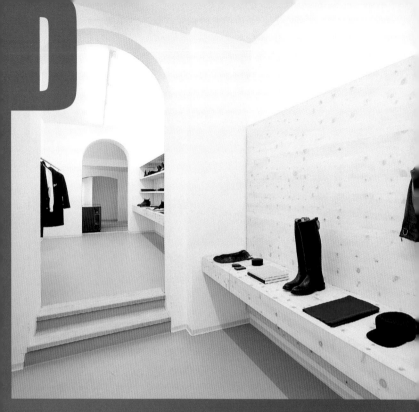

Created in 2001 as a product design label, HALTBAR added clothing to its line two years later. The name is synonymous with quality pieces that are modern and time-less rather than luxury items that quickly go out of fashion. Everything is made in Germany by small businesses using traditional techniques. Run by Kathleen König, the store not only sells the label's own collections but also fine accessories by other designers, such as shoes by Ann Demeulemeester.

2001 zunächst als Label für Produkt-design gegründet, nahm HALTBAR zwei Jahre später auch Kleidung mit ins Programm. Der Name steht für reduzierte Lieblingsstücke, die qualitativ hochwertig und modern, aber keine Luxusartikel mit Verfallsdatum sind. Gefertigt wird nur in Deutschland, man setzt hier auf traditionelle Handwerksbetriebe. Im von Kathleen König geführten Laden gibt es neben den eigenen Kollektionen auch feine Accessoires anderer Label wie Schuhe von Ann Demeulemeester.

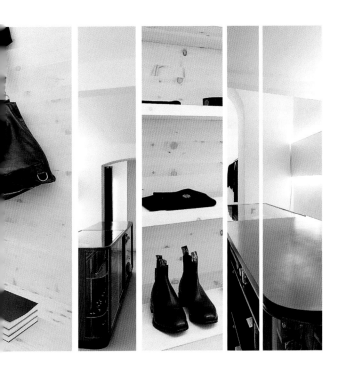

HALTBAR

Pestalozzistraße 28 // Isarvorstadt
Tel.: +49 (0)89 76 75 83 80
www.haltbar.de

Mon–Fri 11 am to 7 pm
Sat 11 am to 4 pm
U1, U2, U3, U6, Tram 16, 17, 18, 27 Sendlinger Tor

Sebastian Steinacker's bookstore on Rumfordstraße is one of the best in Munich. The selection of international books and magazines is unsurpassed, both in quantity and quality. The enormous spectrum of art and design books is presented in large rooms that look like a gallery. Customers who aren't local can shop the online store for publications on fashion, photography, animation, illustration, architecture, design, typography, and hip-hop.

Sebastian Steinackers Laden in der Rumfordstraße ist einer der besten Münchens. Und das in Masse und Klasse bestechende Angebot an internationalen Büchern und Magazinen ist sowieso unübertroffen. Die großzügigen Räume, in denen das riesige Spektrum von Kunst- und Designtiteln präsentiert wird, kommen optisch wie eine Galerie daher. Fernen Freunden von Mode, Fotografie, Animation, Illustration, Architektur, Design, Typografie und Hip-Hop sei auch der Online-Shop empfohlen.

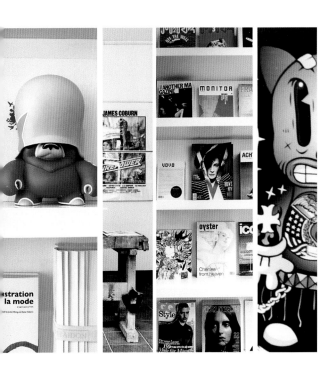

SODA

Rumfordstraße 3 // Isarvorstadt
Tel.: +49 (0)89 20 24 53 53
www.sodabooks.com

Mon–Fri 10 am to 7 pm
Sat 10 am to 6 pm
S1–8, U3, U6 Marienplatz
Tram 17, 18 Reichenbachplatz

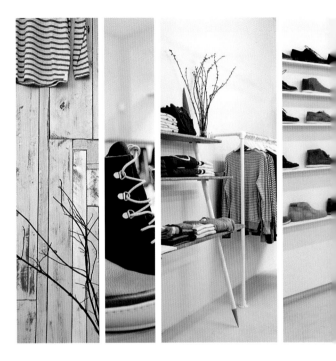

FOLK CLOTHING

Amalienstraße 44 // Maxvorstadt
www.facebook.com/pages/Folk-Munich

Mon–Sat 11 am to 7 pm
U3, U6 Universität

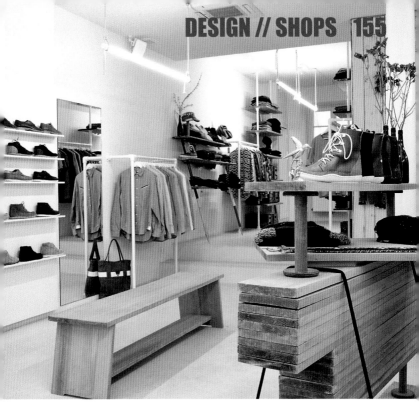

In line with the spirit of the times, the London label, created in 2001, focuses on quality materials, classic cuts, and functional designs with small, individual variations. Folk Clothing is unisex, leaning towards the masculine and offering unabashedly beautiful shoes for women. What makes the Munich store special—in addition to Philip Stolte, who also manages Harvest—is the interior featuring a marble head by sculptor Paul Vanstone: it's reminiscent of school PE classes and a day at the beach.

Dem Zeitgeist entsprechend setzt das 2001 gegründete Londoner Label auf gute Materialien, klassische Schnitte und sachliches Design, mit kleinen, individualistischen Abweichungen. Folk Clothing ist Unisex, mit der Tendenz zum Männlichen und unverschämt schönem Schuhwerk für Frauen. Für den Münchner Laden spricht, neben Philip Stolte, der auch Harvest führt, außerdem das Interieur rund um den Marmorkopf des Künstlers Paul Vanstone: Es erinnert an den Sportunterricht und einen Tag am Meer.

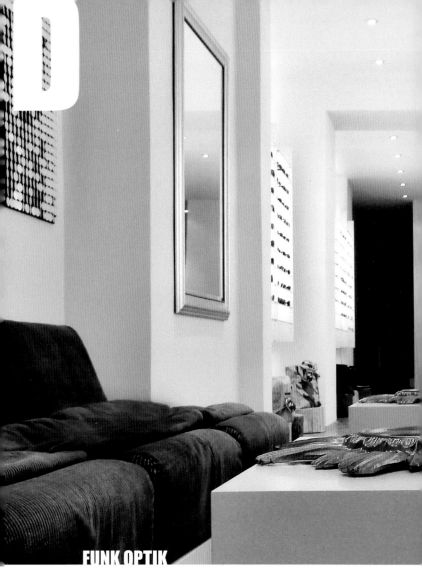

D

FUNK OPTIK

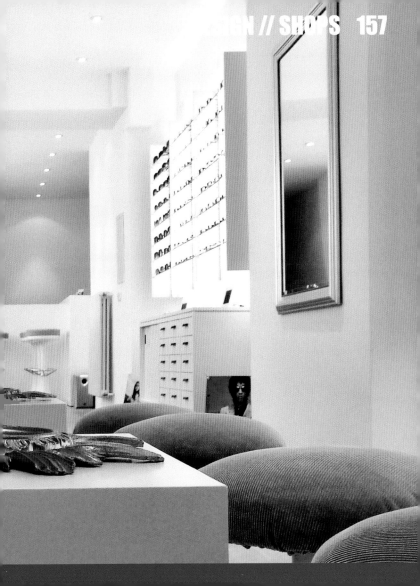

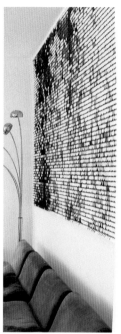

FUNK OPTIK

Schellingstraße 18 // Maxvorstadt
Tel.: +49 (0)89 28 77 99 99
www.funkstore.de

Mon–Fri 10 am to 7 pm
Sat 10 am to 6 pm
U3, U6 Universität

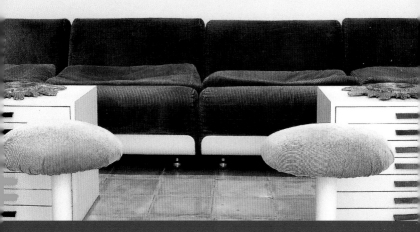

A last name like "Funk" practically obliges its owner to be cool, and Dieter Funk has lived up to his name. This music nerd designed his first glasses when he was a trainee optician. He started his company in 1992, offering frames that were considered bold then but have since become mainstream, and promoted his brand with a flair not typically seen in the industry. Legendary parties and celebrity friends and fans like Busta Rhymes propelled this Bavarian brand to cult status.

Funk wie funky: So ein Nachname verpflichtet geradezu zur Coolness. Dieter Funk hat also alles richtig gemacht. Schon als Optiker-Azubi entwarf der Musiknerd die ersten Brillen. 1992 gründete er seine Firma, die mit damals gewagten, heute vom Mainstream adaptierten Modellen und einem branchenunüblichen Auftritt von sich reden machte. Die legendären FUNK-Partys und prominente Freunde und Fans wie Busta Rhymes haben das Übrige zum Kultstatus der bayerischen Marke beigetragen.

The teNeues bookstore next to Freso Home at the corner of Brienner Straße and Oskar-von-Miller-Ring is a dangerous place. Once you start delving into the many photo books, it's easy to lose track of time—and forget the fact that you're in a store. Designed by Paschen & Companie, the publishing house's book lounge is furnished in dark wood and resembles a private library. With its comfortable ambience, it's the perfect setting to read up on exciting travel destinations and design.

Der Buchladen von teNeues an der Ecke Brienner Straße / Oskar-von-Miller-Ring bei Freso Home ist tückisch. Wenn man sich erst einmal in einen der vielen Fotobände vertieft hat, vergisst man leicht die Zeit – und die Tatsache, dass man sich in einem Geschäft befindet. Paschen & Companie haben die in dunklem Holz gehaltene Leseecke des Verlags im Stil einer privaten Bibliothek gestaltet. In gemütlicher Atmosphäre kann man sich bestens zu den Themen Reise und Design inspirieren lassen.

TENEUES STORE @ FRESO HOME

Brienner Straße 14 // Maxvorstadt
Tel.: +49 (0)89 22 80 79 76
www.fresohome.de

Mon–Fri 10 am to 7 pm
Sat 10 am to 4 pm
U3, U4, U5, U6 Odeonsplatz

JAPANALIA

Herzogstraße 7 // Schwabing
Tel.: +49 (0)89 34 94 54
www.japanalia.de

Mon–Fri 10 am to 6.30 pm
Sat 10 am to 4 pm
U3, U6, Tram 23 Münchner Freiheit

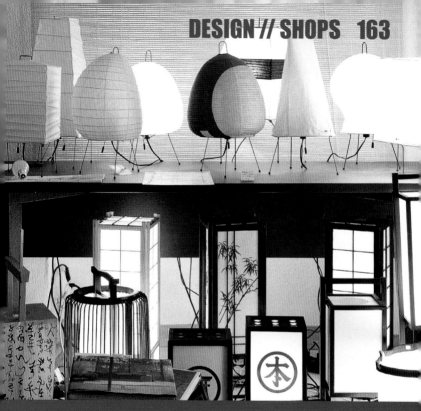

This small space on Herzogstraße is much more than just a furniture store. For over 20 years, Denise Pullirsch has been acting as a cultural intermediary, drawing on her extensive knowledge and obvious love for the Land of the Rising Sun. Her cornucopia of treasures includes fabrics, kimonos, tatamis, futons, as well as a complete range of utensils for meditation, the tea ceremony, and calligraphy. The fragile paper lanterns by sculptor Isamu Noguchi deserve special mention.

Der kleine Japanladen in der Herzogstraße ist viel mehr als nur ein Einrichtungs-geschäft. Seit über 20 Jahren betreibt hier Denise Pullirsch als Botschafterin des traditionellen Japans mit großem Wissen und offensichtlicher Liebe zur Sache Kulturvermittlung. Ein Teil ihres Schatzes von unermesslicher Fülle sind: Stoffe, Kimonos, Tatamis, Futons, alle Utensilien für die Meditation, die Teezeremonie und die Kalligrafie. Und die zarten Papierlampen des Bildhauers Isamu Noguchi.

INGO MAURER

It all started in the 1960s with a naked light bulb, dangling from a hotel room ceiling. It inspired Ingo Maurer's first lamp, "Bulb," which, like many others after it, is now part of the design collection of the Museum of Modern Art in New York. Driven by a love of light, the designer has been combining visual beauty with technical sophistication for over 40 years, earning more awards and accolades than anybody can count. A visit to his showroom oasis in Schwabing is an absolute must, even for design philistines. Best take the U-Bahn to the Münchner Freiheit station (redesigned by Maurer); from there it's just a ten minutes walk to the showroom. Maurer also created the lighting concepts for the U-Bahn stations Westfriedhof and Am Moosfeld. One of his next large-scale projects is the redesign of the mezzanine of the S-Bahn and U-Bahn station at Marienplatz, scheduled to start in 2012.

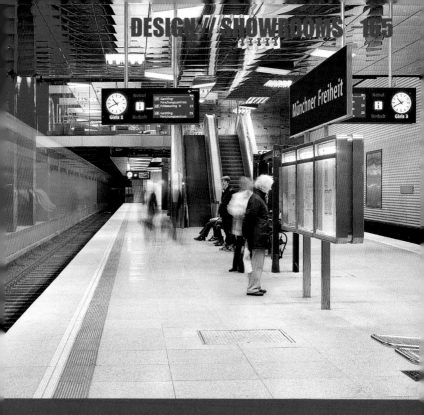

Auslöser war eine Glühbirne, die in einem Hotelzimmer in den 1960ern nackt von der Decke baumelte. So entstand die erste Lampe „Bulb", die wie viele weitere Lampen von Ingo Maurer zum Designkanon der MoMA-Sammlung in New York gehört. Angetrieben von der Liebe zum Licht verbindet der mit Auszeichnungen und Ehrungen überhäufte Designer seit Jahrzehnten visuelle Schönheit mit technischer Raffinesse. Ein Besuch in seiner oasengleichen Zentrale in Schwabing ist ein Hochgenuss und absolute Pflicht, übrigens auch für Designbanausen. Am besten man nimmt die U-Bahn bis zur von Ingo Maurer umgestalteten Station Münchner Freiheit, von hier aus sind es nur zehn Gehminuten bis zum Showroom. Auch die Beleuchtung in den U-Bahn-Stationen Westfriedhof und Am Moosfeld wurde von ihm entworfen. Ein groß angelegtes Projekt ist die Neugestaltung des Zwischengeschosses der S- und U-Bahn-Station Marienplatz, das ab 2012 realisiert werden soll.

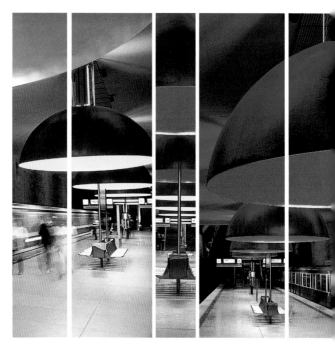

U-BAHNHOF WESTFRIEDHOF

Orpheusstraße
U1 Westfriedhof

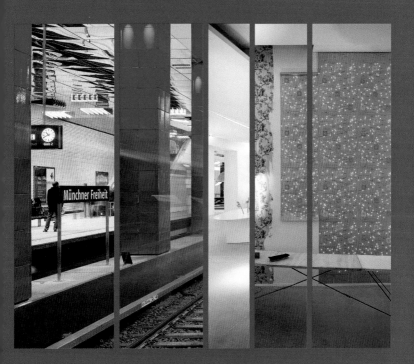

U-BAHNHOF
MÜNCHNER FREIHEIT

Leopoldstraße 82
Schwabing-West

U3, U6 Münchner Freiheit

SHOWROOM

Kaiserstraße 47 // Schwabing
Tel.: +49 (0)89 38 16 06 91
www.ingo-maurer.com

Tue–Fri 11 am to 7 pm, Sat 11 am to 4 pm
U3, U6, Tram 23 Münchner Freiheit
U2 Hohenzollernplatz
Tram 12, 27, Bus 53 Kurfürstenplatz

Luckily, Saskia Diez never turned her back on jewelry. After training as a goldsmith, she studied industrial design and planned for a future in that industry. Then things changed, and shortly after graduation she launched her first jewelry collection called "Diamonds." Her pieces have breathtaking grace and beauty; they are light and yet possess depth. Her showroom was designed in cooperation with her husband, renowned industrial designer Stefan Diez.

Glücklicherweise kam Saskia Diez nie vom Schmuck los. Die gelernte Goldschmiedin studierte Industriedesign und plante ihre berufliche Zukunft auch eher in diese Richtung. Andere Ideen ließen sie jedoch schon kurz nach dem Studium mit der ersten Kollektion „Diamonds" in Serie gehen. Ihre Stücke sind von einer atemberaubenden Anmut und Schönheit, sie sind leicht und haben trotzdem Tiefe. Das Design ihres Showrooms ist eine Koproduktion von ihr und ihrem Mann, dem gefeierten Industriedesigner Stefan Diez.

SASKIA DIEZ

Geyerstraße 20 // Isarvorstadt
Tel.: +49 (0)89 22 84 53 67
www.saskia-diez.com

Mon–Fri 10 am to 1 pm, 2 pm to 6 pm,
and on appointment
Bus 58 Kapuzinerstraße

SALON NEMETZ

Sternstraße 13 // Lehel
Tel.: +49 (0)89 23 68 41 41
www.facebook.com/SalonNemetz

Call for details
U4, U5 Lehel

Who could ever take on Christina Nemetz, also known as the "ringmaster of Munich hairdressers"? Designliga accepted the challenge and created a fabulous arena where Madame Nemetz can give free reign to her coiffure skills. At the same time, the design is also mindful of the fact that many customers like to linger after their hair is done. The furnishings are a delightful mixture of Alice's Wonderland, a cabinet of curiosities, and an over-sized Tetris game.

Wer nimmt es mit Christina Nemetz auf, auch bekannt als die „Zirkusdirektorin der Münchner Friseure"? Die Designliga hat es gewagt und ihr eine wundervolle Manege geschaffen, in der Madame Nemetz ihr handwerkliches Können entfalten kann, die aber auch der Tatsache Sorge trägt, dass man in ihrem Salon gerne mal etwas länger bleibt. Die Einrichtung ist eine herrliche Mischung aus Alice' Wunderland, Kuriositätenkabinett und überdimensionalem Tetris-Spiel.

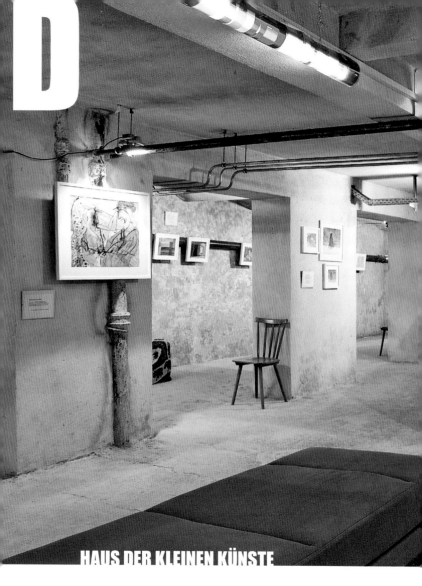

HAUS DER KLEINEN KÜNSTE

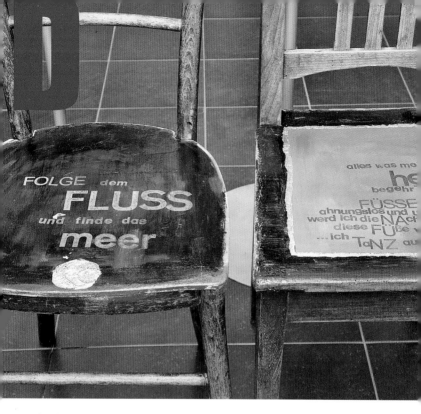

This "grassroots" gallery near the Isartor is unusual in the best sense of the word—especially for Munich. Since 2008, Bahar Auer has been promoting creative talents by offering them a 650 sq. ft. (sales) platform. The categories include fashion, art, and design; exhibitions change every two or three months. The result is a wild mix of products as gutsy and exciting as the gallery owner herself. The basement regularly hosts group exhibitions such as "For More Personal Freedom."

Die „Graswurzel"-Galerie in der Nähe des Isartors ist im besten Sinne ungewöhnlich, vor allem für München. Bahar Auer fördert hier seit 2008 kreative Menschen, indem sie ihnen auf 60 m² Ladenfläche eine (Verkaufs-)Plattform bietet. Es gibt die Module Mode, Kunst und Design, die alle zwei bzw. drei Monate wechseln. Dabei entsteht eine wilde Mischung, die mutig und spannend ist, so wie die Galeristin selbst. Im Keller finden regelmäßig Gruppenausstellungen statt wie „Für mehr persönliche Freiheit".

HAUS DER KLEINEN KÜNSTE

Buttermelcherstraße 18 // Isarvorstadt
Tel.: +49 (0)89 2 01 44 80
www.hausderkleinenkuenste.de

Wed–Sat 11.30 am to 7 pm
S1–8 Isartor

ART

ARCHITECTURE

MAP 177

DESIGN

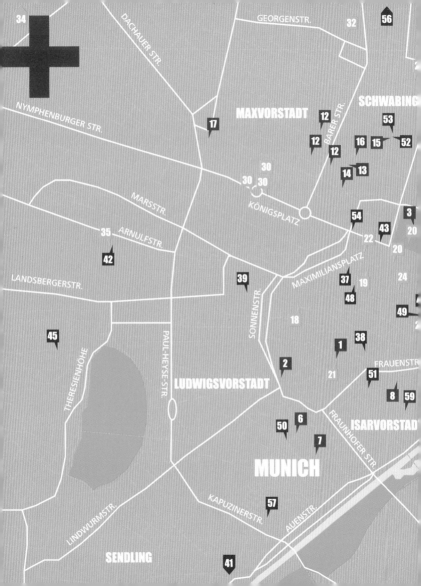

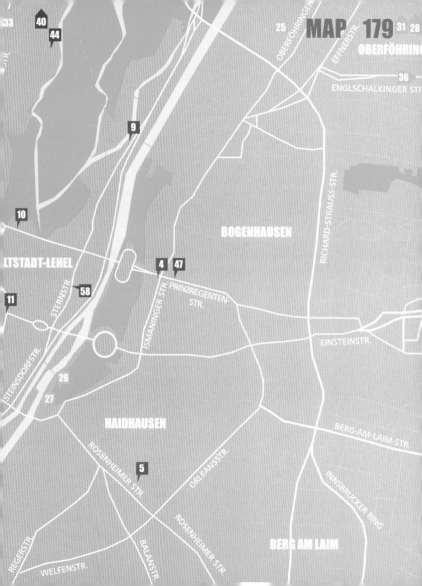

BOGENHAUSEN

Today, this district is famous for being a very exclusive residential area with many beautiful art nouveau mansions. Also, it is home to the golden Friedensengel and the neoclassical Prinzregententheater.

FRÖTTMANING

Fröttmaning is part of Freimann. Apart from the super-modern Allianz Arena, the district consists of residential areas, commercial zones, and Germany's biggest "students' city."

HAIDHAUSEN

A beautiful historical district, with the so called Au ("meadow") by the river and a lot of green. Haidhausen used to be the craftsmen district—many of their former little houses are still intact, but now renovated and mostly unaffordable for "normal" people.

HALLBERGMOOS

Strictly speaking not a district, but an independent municipality belonging to the administrative district of Freising. With the opening of the airport in 1992 its population increased considerably.

ISARVORSTADT

The most popular district for living, going out, and for seeing and being seen. It is made up of three quarters: the posh yet laid back and gay-friendly Glockenbachviertel and Gärtnerplatzviertel, and the cool Schlachthofviertel with the graffiti hall of fame.

LEHEL

A very sophisticated district with many impressive old (thoroughly renovated) buildings, and Prinzregentenstraße, the city's "museum mile." The southern part of the Englischer Garten is part of Lehel.

LUDWIGSVORSTADT

Arguably the liveliest district in Munich—also because of the intriguing mix of red light vibe and multicultural character in the Bahnhofsviertel, the quarter by the train station. The Theresienwiese, the site of the "Oktoberfest," makes it a major destination.

MAXVORSTADT

An amazing district, with a whole different, almost mediterranean vibe. The universities are located here, as well as several of the best galleries and, of course, museums. Great for sightseeing, shopping, and chilling out.

MAP 181

OBERFÖHRING

It belongs to the vast district Bogenhausen. Oberföhring is great for walking and cycling, and short trips to less exposed beer gardens, like the one next to the St. Emmeram chapel.

OLD TOWN

This is the political, cultural, and commercial center of the city. Countless landmarks and important sights are to be found here, like the Frauenkirche, the Viktualienmarkt, and the infamous Hofbräuhaus.

SCHWABING

Schwabing is famous for the Englischer Garten, the numerous art nouveau buildings, and for its wild past. At the end of the 19th century it was the place to be for the painters of "Der Blaue Reiter," writers like Thomas Mann, and a host of artists, actors and satirists.

SCHWABING-WEST

Schwabing's sister is just as beautiful, yet maybe more relaxed. Many artists used to live here, the poet Rainer Maria Rilke for example. The market at Elisabethplatz is a cosy and authentic alternative to the Viktualienmarkt in the city center.

SCHWANTHALERHÖHE

Also dubbed Westend, this district has seen a steady increase of popularity in the past years. The conversion of former industrial areas into residential space has brought change to the quarter.

UNTERFÖHRING

This municipality on the north-eastern brink of the city is mostly known for its status as one of the most significant hubs of the media industry.

EMERGENCY

| Ambulance/Fire | Tel.: 112 |
| Police | Tel.: 110 |

ARRIVAL

BY PLANE
Flughafen München
Information on arrivals and departures,
security regulations etc.
Tel.: +49 (0)89 9 75-00
www.munich-airport.de

32 km / 20 miles northeast of the city center.
National and international flights. To the city
center take the S-Bahn S8 (eastbound) or S1
(westbound), which will take about 45 mi-
nutes. Or the airport bus to North Schwabing
and Munich main station, leaving the airport
from 5.28 am to 7.28 pm every 20 minutes.
Return busses leave the main station from
5.10 am to 7.50 pm every 20 minutes. The
bus ride will take approximately 40 minutes.
www.s-bahn-muenchen.de
www.airportbus-muenchen.de

BY TRAIN
Hauptbahnhof München
Bahnhofplatz 1
www.hauptbahnhof-muenchen.de
Munich's main station is located conveniently
close to the Marienplatz and is well
connected with all the main S-Bahn trains
(S1–S8) and U-Bahn lines U1, U2, U4 and
U5, Trams 17–21, Busses 58 and 100.
www.bahn.de
Official website of the Deutsche Bahn, for
detailed information on train schedules,
fares etc.

TOURIST INFORMATION

Tourismusamt München
Sendlinger Str. 1
80331 München
Tel.: +49 (0)89 23 39 65 00
Fax: +49 (0)89 23 33 02 33

Write to tourismus@muenchen.de,
visit **www.muenchen.de/tam**
or call the service hotline
+49 (0)89 23 39 65 55
for assistance in planning and organising
your trip, or any kind of advice.

Tourist Information Hauptbahnhof
(main station), Bahnhofplatz 2,
open Mon–Sat 9 am to 8 pm,
Sun 10 am to 6 pm.

Tourist Information Marienplatz,
in the Neues Rathaus (town hall),
open Mon–Fri 10 am to 8 pm,
Sat 10 am to 5 pm, Sun 10 am to 4 pm,
closed on holidays.

ACCOMODATION

www.muenchen.de
Download an extensive list with accommo-
dation options or send an e-mail to
hotelservice@muenchen.de

TICKETS

Book online on **www.muenchen.de**
or at a München Ticket booth:

München Ticket im Hauptbahnhof,
Mon–Sat 10 am to 8 pm.
München Ticket im Rathaus,
Mon–Fri 10 am to 8 pm, Sat 10 am to 4 pm.
München Ticket Glashalle im Gasteig,
Mon–Fri 10 am to 8 pm, Sat 10 am to 4 pm.
Info-Pavillon am Olympia-Eissportzentrum,
Mon–Fri 1 pm to 6 pm, Sat 10 am to 4 pm.

CityTourCard – 1 day or 3 day ticket for all
public transportation in the MVV inner dis-
trict or entire network, as well as discounts
on over 30 tourist destinations. Available as
single or partner tickets from ticket vend-
ing machines and ticket booths. Prices from
9.90 EUR to 51.50 EUR.
More information on
www.citytourcard.com

GETTING AROUND

PUBLIC TRANSPORTATION
www.mvv-muenchen.de
Münchner Verkehrs- und Tarifverbund
(MVV), Service Line for information on time
tables and tariffs
Tel.: +49 (0)89 41 42 43 44
www.mvg-mobil.de
Münchner Verkehrsgesellschaft (MVG), the
operator of the U-Bahn, buses and trams
Tel.: +49 (0)1803 44 22 66
(9 ct/min. from German land line)
www.s-bahn-muenchen.de
S-Bahn München
Tel.: +49 (0)1805 66 10 10
(14 ct/min. from German land line)

TAXI
Tel.: +49 (0)89 45 05 40
Tel.: +49 (0)89 2 16 10
Tel.: +49 (0)89 1 94 10

BICYCLE RENTAL

www.radiustours.com
Radius Tours & Bike Rental,
Tel.: +49 (0)89 55 02 93 74,
from 14.40 EUR per day.
Office hours during summer:
April 1st–October 15th
Mon–Fri 9 am to 6 pm
Sat–Sun and holidays 9 am to 8 pm.
Winter:
October 16th–March 31st dependent
on the weather
closed December 24th–Januar 1st.
The Bike Rental is located beside the
Radius Tours sales office, opposite
platform 32-34 in the main station
(Hauptbahnhof).
www.callabike-interaktiv.de
Call a bike
Tel.: +49 (0)7000 5 22 55 22
(Mon–Fri 9 am to 6 pm 12,6 ct/min., at
off-peak times 6,3 ct/min. from German
land line). Registration online for 7.50 EUR
or 15 EUR by phone. Rent is 8 ct/min. and
15 EUR/day.

CAR RENTAL

Beside the international rental car companies
there are some Munich based like:
www.buchbinder.de
www.autoverleih-sander.de
www.autovermietung.de
www.avm-autovermietung.de

CITY TOURS

BUSES AND TRAMWAYS

Bus No. 100, the "Museum Line", goes from
the main station to Ostbahnhof, stopping
at Königsplatz, Pinakotheken, Odeonsplatz,
Haus der Kunst, Friedensengel and passing
22 museums on its route.
Tram lines 17, 18, 19, and 27 are great ways
to discover the city and its most beautiful
sights.
www.spurwechsel-muenchen.de
City Tour by tram in a real "oldtimer" built
in 1958. The tour takes about 50 minutes
and takes you to all the sights in the center
of Munich.
From June–October. English tour available
once a week.

SIGHTSEEING BUSES

www.sightseeing-munich.com
SIGHTseeing Gray Line,
Tel.: +49 (0)89 54 90 75 60
www.citysightseeing-muenchen.de
CitySightseeing
Tel.: +49 (0)176 86 47 41 24

BOAT

www.flossfahrt.de
Flößerei Josef Seitner,
Tel.: +49 (0)8171 7 85 18
Float down the Isar, from Wolfratshausen
to Thalkirchen, on a raft.

GUIDED TOURS

All of them offer different themed walks
and/or bicycle tours:
www.weisser-stadtvogel.de
Weis(s)er Stadtvogel,
Tel.: +49 (0)89 2 03 24 53 60
www.stattreisen-muenchen.de
Stattreisen, Tel.: +49 (0)89 54 40 42 30
www.spurwechsel-muenchen.de
Spurwechsel, Tel.: +49 (0)89 6 92 46 99
www.radiustours.com
Radius Tours, Tel.: +49 (0)89 55 02 93 74

ART & ARCHITECTURAL TOURS

www.muenchen-stadtfuehrung.de
Kunst und Kulturführungen in München
und Bayern – Art and culture tours of
Munich and Bavaria
Tel.: +49 (0)8131 8 68 00 or
Tel.: +49 (0)170 3 41 63 84
The Tourismusamt München (Tourist Office)
also helps with finding special tours on
modern and historical architecture
in Munich.
Tel.: +49 (0)89 2 33 30-234/204 or
e-mail to gf.tam@muenchen.de.

ART & CULTURE

www.museen-in-muenchen.de
Portal of museums in Munich
www.muenchner-galerien.de
Galleries in Munich
www.muenchen.de
Official website of the city. Check their
"Events Calendar" and "Cinema Program".
www.kultmuenchen.de
Cultural events in Munich

GOING OUT

www.derkongress.com
Music and culture
www.in-muenchen.de
Free magazine
www.munichx.de
www.muenchen.de
Featuring the most extensive overview of
restaurants and cafés in Munich

EVENTS

JANUARY TO MARCH

www.lange-nacht-der-architektur.de
Lange Nacht der Architektur – Long night of architecture (January, biannually)
www.nockherberg.com
Nockherberg Starkbierfest – the "Strong beer" festival (March)

APRIL TO JUNE

www.stroke-artfair.com
Stroke Urban Art Fair (May)
www.auerdult.de
Maidult – traditional fun fair around May 1st, with beer and food tents, and stands with local artisanry, takes place three times a year.
www.dokfest-muenchen.de
International Documentary Film Festival (May)
www.muenchner.de/musiknacht
Lange Nacht der Musik – Long night of music (May)
www.bayerische.staatsoper.de
Opernfestspiele – Munich Opera Festival (June/July)
www.tollwood.de
Tollwood Summer Festival (June/July)
www.filmfest-muenchen.de
Munich International Film Festival (June/July)

JULY TO SEPTEMBER

www.auerdult.de
Jakobidult – Traditional fun fair (July/August)
www.klassik-am-odeonsplatz.de
The classical music open-air festival at Odeonsplatz (July)
www.oktoberfest.de
Official Wiesn website (September/October)

OCTOBER TO DECEMBER

www.muenchner.de/museumsnacht
Lange Nacht der Museen – Long night of the museums (October)
www.auerdult.de
Kirchweihdult – Traditional fun fair (October)
www.tollwood.de
Tollwood Winter Festival (November/December)

Cover photo (Blue Spa at Hotel Bayerischer Hof) courtesy of Hotel Bayerischer Hof

Back cover photos courtesy of Münchner Stadtmuseum; Franz Kimmel/courtesy of Jüdisches Zentrum am Jakobsplatz; Roland Bauer

ART

P 8–9 (Münchner Stadtmuseum) p 8 and p 9 middle and right photo from exhibition "Typisch München!", all photos courtesy of Münchner Stadtmuseum
p 10–11 (Kirsch & Co) artworks by Tim Wolff, "Madness to Society", all photos courtesy of Kirsch & Co
p 12–15 (Kunstverein München) p 12–13 art by Cathy Wilkes, no title, 2011, Giti Nourbakhsch Gallery, Berlin and The Modern Institute, Glasgow, p 14 left art by Cathy Wilkes, Galilee, 2010, Rennie Collection, Vancouver, p 14 middle art "She's pregnant again" by Cathy Wilkes, 2005, The Arts Council Collection, Southbank, p 14 right art by Cathy Wilkes, archive materials, p 15 "Galilee" by Cathy Wilkes, 2010, Rennie Collection, Vancouver, all photos by U. Gebert
p 16–17 (Villa Stuck) all photos by Jens Weber
p 18–19 (Lothringer13) p 19 right art "was ist zu tun" by August Ahlquist/courtesy of Lothringer13, all other photos by Fritz Beck & Verena Kathrein (further credited as fb & vk)
p 20–21 (candela project gallery) p 20 "Kittywakes" by Hans Strand , 2008, "River Delta & Lake, Central Highlands" by Hans Strand, 2009 (left wall), and "Lady Midday 1" by Irek Kielczyk, p 21 left and right art by Chad Coombs/Polaroid Series, "Expired,", p 21 middle courtesy of candela project gallery
p 22–23 (Galerie Wittenbrink) all photos courtesy of Galerie Wittenbrink

p 24–25 (Weltraum) p 25 right by fb & vk, all other photos courtesy of Weltraum
p 26–27 (Galerie Reygers) p 26 left courtesy of Galerie Reygers, all other photos by Roland Bauer (further credited as rb)
p 28–31 (Haus der Kunst + Sammlung Goetz im Haus der Kunst) p 28–29 text sculpture by Lawrence Weiner, photo by Jens Weber, p 30 left and right photo by Wilfried Petzi, p 30 middle photo by Marino Solokhov/Haus der Kunst 2011, p 31 left art by Omer Fast, A Tank Translated, 2002/ courtesy of Sammlung Goetz, p 31 middle right art by Scar Munoz, p 31 right art by Hans Op de Beeck, photos by Wilfried Petzi
p 34–35 (MaximiliansForum) p 34 left photo by Dirk Eisel, p 34 middle and 35 art by Ayzit Bostan, photos by Jörg Koopmann
p 36–39 (Alte Pinakothek + Neue Pinakothek + Pinakothek der Moderne) p 36–37 photo by Josef Widgruber/Fremdenverkehrsamt München, p 38 left and middle photo by Sibylle Forster/Pinakothek der Moderne, p 38 middle artwork „Buscando la Luz, 1997" by Eduardo Chillida/VG Bild-Kunst, Bonn 2011, p 38 right photo by Bernd Römmelt/Fremdenverkehrsamt München, p 39 middle right by Jens Weber, all other photos by Haydar Koyupinar/ courtesy of Alte Pinakothek & Neue Pinakothek
p 40–43 (Die Neue Sammlung) p 40–41 "LC4" by Le Corbusier/VG Bild-Kunst, Bonn 2011, p 42 Zaha Hadid and Luigi Colani, p 43 left "Paternoster" by Ron Arad, all photos by Rainer Viertlböck
p 44–45 (Galerie an der Pinakothek der Moderne - Barbara Ruetz) paintings by Kai Feldschur, sculptures by Ulrike Goelner, all photos by rb
p 46–47 (Galerie Rüdiger Schöttle) artwork by Patty Chang, all photos by fb & vk
p 48–51 (Museum Brandhorst) p 48–49 "Lepanto"

by Cy Twombly, p 51 left art by Cy Twombly "Roses", all photos by Haydar Koyupinar

p 52–53 (Wandergalerie Stephanie Bender) exhibition " Visual Diaries/Girls," artwork by Sara Gomes, Madi Ju, Helen Korpak, Manuela de Laborde, Skye Parrot, Olga Perevalova, Nuria Rius, Florencia Serrot, Agnes Thor, Sophie Van de Perre, Harley Weir, all photos by fb & vk

ARCHITECTURE

p 56–57 (Augustinerbräu) all photos by rb
p 58–61 (Fünf Höfe) architecture by Herzog & de Meuron, p 58–59 photo by rb, p 61 middle "Sphere" by Olafur Eliasson, all photos courtesy of Union Investment
p 62–65 (Residenz + Hofgarten) p 62–63 and 64 right photo by rb, p 64 left by Fritz Mader/Fremdenverkehrsamt München, p 64 middle by Wilfried Hösl/Fremdenverkehrsamt München, p 65 left and middle photo by Torsten Krüger/Fremdenverkehrsamt München, p 65 right by Jörg Lutz/Fremdenverkehrsamt München
p 66–67 (Jüdisches Museum München) architecture by Wandel Hoefer Lorch, p 66 left and right photo by Roland Halbe, p 66 middle by Franz Kimmel/all photos courtesy of Jüdisches Museum München
p 68–69 (Literaturhaus) architecture by Kiessler + Partner, p 68 left photo by Juliana Krohn, p 68 middle left art "Mehr Erotik bitte!" by Jenny Holzer, photo by Lissy Mitterwallner, p 68 middle right photo by Heidi Vogel, p 68 right and 69 photo by Heidi Maier
p 70–71 (Münchner Kammerspiele) p 70 left and middle photo by Andreas Pohlmann, p 70 right photo by rb, p 71 photo by Jeanne-Marie Katajew
p 72–73 (Nationaltheater) p 72 photo by Ulrike Romeis/Fremdenverkehrsamt München, p 73 all photos by Wilfried Hösl/courtesy of Bayerische Staatsoper
p 74–77 (Allianz Arena) architecture by Herzog & de Meuron, all photos by Bernd Ducke/courtesy of Allianz Arena
p 78–79 (Muffatwerk) and p 80 photos courtesy of Muffatwerk, p 81 left photo by Zooey Braun/artur/courtesy of Muffatwerk, p 81 middle and right photo by rb
p 82–85 (Müller'sches Volksbad) all photos by fb & vk
p 86–87 (Terminal 2 Flughafen München) all photos courtesy of MFG
p 88–89 (Akademie der Bildenden Künste) annex by Coop Himmelb(l)au, all photos by fb & vk
p 90–93 (Königsplatz + Glyptothek + Kunstbau) p 93 left photo by Alfred Müller/Fremdenverkehrsamt München, p 93 middle photo by Ulrike Romeis/Fremdenverkehrsamt München, all other photos by rb
p 96–97 (Sammlung Goetz) architecture by Herzog & de Meuron, all photos by Franz Wimmer/courtesy of Sammlung Goetz
p 98–99 (AIT-ArchitekturSalon) all photos by rb
p 100–101 (Tramhaltestelle Münchner Freiheit) architecture by OX2architekten, all photos by fb & vk
p 102–103 (Olympiastadion) architecture by Günter Behnisch and Frei Otto, all photos by rb
p 106–107 (Zentraler Omnibusbahnhof) all photos by rb
p 108–109 (Swiss Re) architecture by BRT Architekten, all photos by Jörg Hempel, 2011

DESIGN

p 112–115 (Hotel Bayerischer Hof + Blue Spa + falk's bar) Blue Spa designed by Andrée Putman, p 115 left and right by rb, all other photos courtesy of Hotel Bayerischer Hof
p 116–117 (LOUIS Hotel) architecture by Hild und K, p 116 photo by Martin N. Kunz (further credited as mk), all other photos by Stefan Braun/courtesy of LOUIS Hotel
p 118–119 (anna hotel) p 118 middle left photo by mk, all other photos courtesy of Geisel Hotels, München
p 120–123 (Hotel La Maison) all photos by rb
p 124–125 (Roecklplatz) interior design by Nitzan Cohen, all photos by rb
p 126–127 (bratar) p 127 left, middle right and right photos by rb, all other photos courtesy of bratar
p 128–129 (deli @ designreisen / designraum) all photos by rb
p 130–133 (Café Reitschule) interior architecture by Palais Mai, all photos by Edward Beierle
p 134–137 (Das neue Kubitscheck) interior design by Designliga, all photos by Pascal Gambarte,
p 138–139 (The Atomic Café) all photos by Gesa Simons
p 140–141 (Käfer Lounge) all photos courtesy of Feinkost Käfer
p 142–143 (Lodenfrey) all photos by rb
p 144–145 (Schwittenberg) all photos by rb
p 148–151 (HALTBAR) all photos by Judith Buss, 2007
p 152–153 (soda) all photos by rb
p 154–155 (Folk Clothing) all photos by rb
p 156–157 (Funk Optik) all photos courtesy of Funk Optik
p 160–161 (teNeues Store @ Freso Home) all photos by rb

p 162–163 (Japanalia) all photos by rb
p 164–167 (Ingo Maurer) p 166 left photo by Jürgen Sauer/Fremdenverkehrsamt München, p 166 middle and right photo by Markus Tollhopf, Hamburg/Ingo Maurer GmbH, p 164–165 and 167 photos by Tom Vack, München/Ingo Maurer GmbH
p 168–169 (Saskia Diez) all photos courtesy of Saskia Diez
p 170–171 (Salon Nemetz) interior design and photos courtesy of Designliga
p 172–175 (Haus der kleinen Künste) p 172, 173 and p 175 right artwork by Jorge Ourcilleon, all photos by rb

Pocket-size Book
www.cool-cities.com

ISBN 978-3-8327-9490-3

ISBN 978-3-8327-9495-8

ISBN 978-3-8327-9484-2

ISBN 978-3-8327-9497-2

ISBN 978-3-8327-9595-5

ISBN 978-3-8327-9488-0

ISBN 978-3-8327-9496-5

ISBN 978-3-8327-9493-4

ISBN 978-3-8327-9489-7

ISBN 978-3-8327-9491-0

COOL
CITIES
ART ARCHITECTURE DESIGN

ISBN 978-3-8327-9435-4

ISBN 978-3-8327-9433-0

ISBN 978-3-8327-9463-7

ISBN 978-3-8327-9464-4

ISBN 978-3-8327-9501-6

ISBN 978-3-8327-9465-1

ISBN 978-3-8327-9502-3

ISBN 978-3-8327-9499-6

ISBN 978-3-8327-9434-7

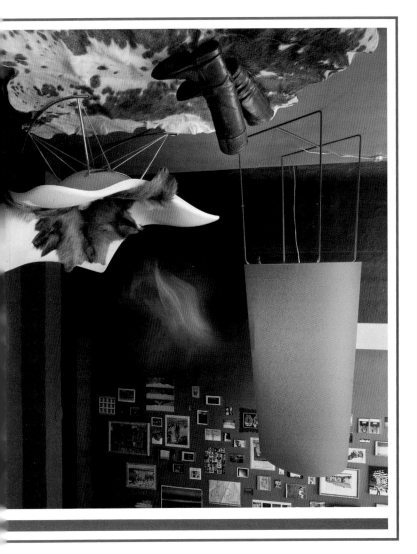

© 2011 Idea & concept by Martin Nicholas Kunz, Lizzy Courage Berlin
Selected, edited, and produced by Aishah El Muntasser

Texts by Aishah El Muntasser

Editorial coordination: Miriam Bischoff
Executive Photo Editor: David Burghardt
Copy Editor: Katharina Döring
Design Assistant: Sonja Oehmke
Imaging and pre-press production: TRIDIX, Berlin
Translation: Übersetzungsbüro RR Communications Romina Russo
Übersetzer: Heather Bock, Romina Russo

© 2011 teNeues Verlag GmbH + Co. KG, Kempen

teNeues Verlag GmbH + Co. KG
Am Selder 37, 47906 Kempen // Germany
Tel.: +49 (0)2152 916-0, Fax: +49 (0)2152 916-111
e-mail: books@teneues.de

Press department: Andrea Rehn
Tel.: +49 (0)2152 916-202 // e-mail: arehn@teneues.de

teNeues Digital Media GmbH
Kohlfurter Straße 41–43, 10999 Berlin // Germany
Tel.: +49 (0)30 700 77 65-0

teNeues Publishing Company
7 West 18ᵗʰ Street, New York, NY 10011 // USA
Tel.: +1 (0)212 627 9090, Fax: +1 (0)212 627 9511

teNeues Publishing UK Ltd.
21 Marlowe Court, Lymer Avenue, London SE19 1LP // UK
Tel.: +44 (0)20 8670 7522, Fax: +44 (0)20 8670 7523

teNeues France S.A.R.L.
39, rue des Billets, 18250 Henrichemont // France
Tel.: +33 (0)2 4826 9348, Fax: +33 (0)1 7072 3482

www.teneues.com

While we strive for utmost precision in every detail, we cannot be held
responsible for any inaccuracies, nor for any subsequent loss or damage arising.

Bibliographic information published by the Deutsche Nationalbibliothek.
The Deutsche Nationalbibliothek lists this publication in the
Deutsche Nationalbibliografie; detailed bibliographic data are
available in the Internet at http://dnb.d-nb.de.

v 1.1
Printed in the Czech Republic
ISBN: 978-3-8327-9501-6

COOL CITIES +

A NEW GENERATION
of multimedia lifestyle travel guides featuring the hippest, most fashionable hotels, shops, dining spots, galleries, and more for cosmopolitan travelers.

VISUAL
Discover the city with tons of brilliant photos and videos.

APP FEATURES
Search by categories, districts, or geolocator; get directions or create your own tour.